IMAGES
of America

YANKEES
BASEBALL
THE GOLDEN AGE

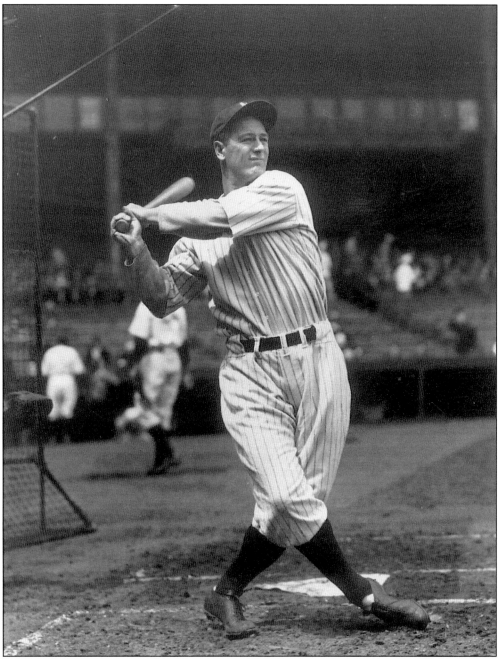

PRIDE OF THE YANKEES. The Yankees' first baseman and captain was taken for granted for much of his career, which included a .340 lifetime batting average, 493 home runs, and 13 consecutive seasons of 100 or more runs batted in, including a league record 184 in 1931. Despite his awesome production, Lou Gehrig is best remembered today for his heroic response to the disease that killed him and now carries his name.

IMAGES
of America

YANKEES
BASEBALL
THE GOLDEN AGE

Richard Bak

ARCADIA
PUBLISHING

Published by Arcadia Publishing
Charleston, South Carolina

Printed in the United States of America

Library of Congress Catalog Card Number: 2004115872

For all general information contact Arcadia Publishing at:
Telephone 843-853-2070
Fax 843-853-0044
E-mail sales@arcadiapublishing.com
For customer service and orders:
Toll-Free 1-888-313-2665

Visit us on the Internet at www.arcadiapublishing.com

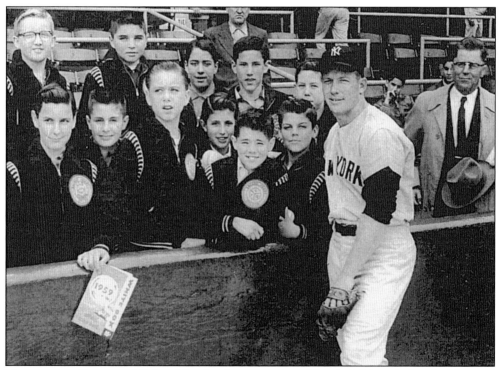

MICKEY AND FRIENDS. Mickey Mantle, the most powerful switch-hitter in baseball history, was a hit with fans at home and on the road, as this picture of him at Chicago's Comiskey Park in 1959 illustrates. "He was like a 15-year-old kid with a grin on the side of his mouth, always having fun," recalled one teammate. "Then he put the uniform on and became the most serious guy in the world."

CONTENTS

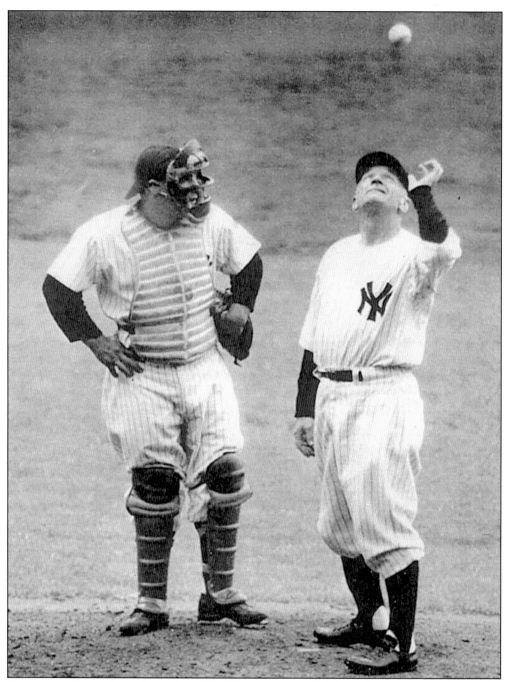

CASEY AND YOGI. Casey Stengel and Yogi Berra, two baseball legends who were as famous for their fractured language as for their winning ways, wait out a pitching change one afternoon during the 1951 season, the midpoint of the Yankees' five straight world championships.

INTRODUCTION

The toughest part of being a success, composer Irving Berlin once remarked, is that you have to keep on being a success. Nowhere is the pressure to win more intense than in New York, where the citizenry is used to having the best in everything, including baseball. Some might say, *especially* in baseball. In this they have been fortunate, for not only have the New York Yankees been the most successful franchise in the annals of baseball, they have been the most successful club in the entire history of team sports.

At no time was the Bronx Bombers' domination more pronounced than between 1920 and 1964. During this period, the Yankees captured 29 American League pennants and won 20 World Series, six of them in four-game sweeps. In 11 different seasons, they won 100 or more games, often outdistancing the runner-up by 10, 13, or even 19 games. They annually dominated All-Star Game selections and typically grabbed the lion's share of post-season awards. They did it with a certain mystique that began with the Murderers' Row teams of the 1920s and was passed on to several generations of players.

"There was something special about being a Yankee back in those years," said pitcher Vic Raschi, a major contributor to the team's five straight world championships between 1949 and 1953. "We believed we were the best and that we couldn't lose. It wasn't arrogance, it was pride. We used to go out there each day with every expectation of winning. And when we didn't win, then it was more than just losing a ball game, because it hurt our pride."

On these pages is a visual record of the Yankees' glory years, an unprecedented run that spanned five decades and included some of the most famous names and memorable moments in the game's long history. Meet Ruth, Lou, Lazzeri, Joltin' Joe, Scooter, Yogi, Casey, Roger, The Mick, and Gene Woodling, who defended the Yankees' monopoly in his retirement. "I didn't think it was unfair how good the Yankees were," said the old outfielder. "I thought that was the way it was supposed to be."

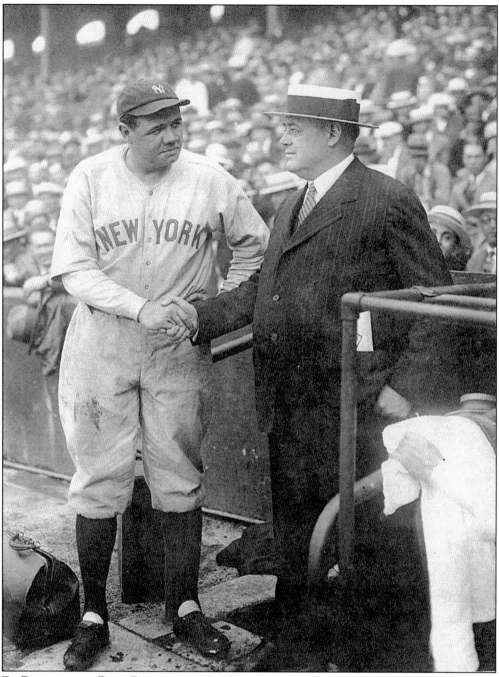

ED BARROW AND BABE RUTH, C. 1930. The two principal engineers of the Yankees' dynasty of the Roaring Twenties and the Depression of the 1930s were general manager Ed Barrow and Babe Ruth, both of whom came over from the Boston Red Sox. Barrow was an intense, two-fisted baseball executive who managed the Red Sox to a world's championship in 1918 and gained renown for switching Ruth, then the league's top southpaw, from the mound to the outfield. During the 1920s, Barrow acquired a steady stream of Red Sox players from Boston owner Harry Frazee, a theatre owner who needed the cash to keep his stage productions going.

One

BUILDING A DYNASTY

THE CONTROVERSIAL CARL MAYS. Among the many transplanted Bostonians on the Yankees' roster was Carl Mays, a stocky right-hander who racked up records of 26-11 in 1920 and 27-9 in 1921, his first two years in New York. His submarine-style pitching motion baffled hitters and on one infamous occasion killed a player. On August 16, 1920, Mays struck Cleveland shortstop Ray Chapman in the temple with a pitch. Chapman fell into a coma and died the following morning, becoming the first and only on-field death in major league history. Roundly vilified, Mays later had to contend with suspicions that he helped throw the 1921 World Series to the Giants. The charges were never proven, but they led to his sale to Cincinnati after the 1923 season.

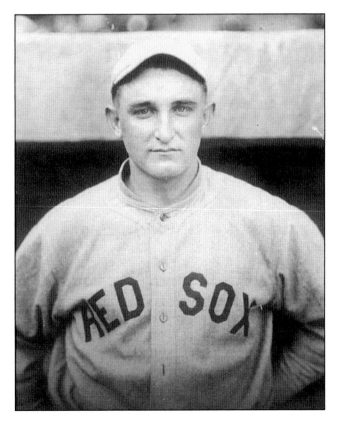

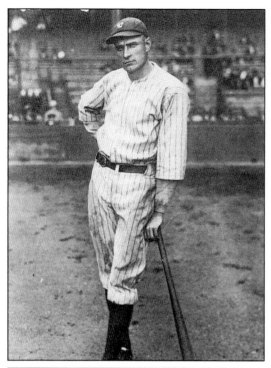

WALLY PIPP. First baseman Wally Pipp became a footnote in baseball history when he took a day off in 1925, allowing a young Lou Gehrig to move permanently into the lineup. Although Pipp hit only 90 home runs during his 15 years in the majors, he twice led the league—in 1916 with 12 and in 1917 with 9.

THE ORIGINAL IRON MAN. Shortstop Everett Scott, acquired from Boston prior to the 1922 season, reeled off a record 1,307-game playing streak that finally ended on May 5, 1925. "The lively ball ended my string," the career .249 hitter said, "not bad legs."

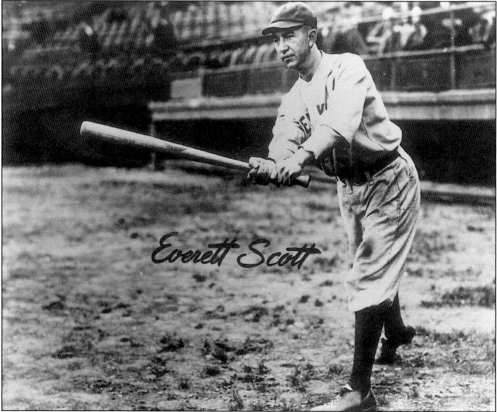

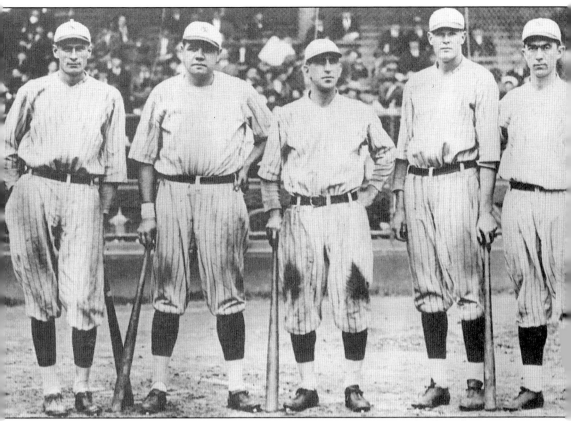

MURDERERS' ROW, 1921. The Yankees won their first pennant in 1921, thanks in large part to a murderous offense. Shown here are, from left to right, as follows: first baseman Wally Pipp, left fielder Babe Ruth, shortstop Roger Peckinpaugh, right fielder Bob Meusel, and third baseman Frank "Home Run" Baker. That summer, Ruth clouted 59 homers, easily outdistancing Meusel and St. Louis' Ken Williams, who tied for second with 24.

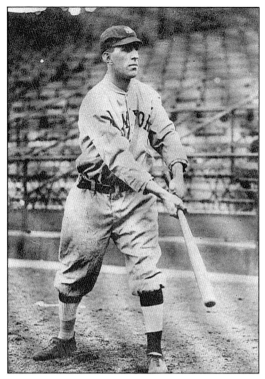

ROGER PECKINPAUGH. The Yankees' shortstop for nine summers was Roger Peckinpaugh, who also managed the club as a 23-year-old during the 1914 season. Sent to Washington after the 1921 season, the former "Boy Wonder" helped lead the Senators to pennants in 1924 and 1925, the only two seasons between 1921 and 1928 that the Yankees failed to capture the flag.

SCHOOLBOY HOYT. Brooklyn schoolboy Waite Hoyt signed with the Giants as a 15-year-old, leading to his inevitable nickname. Acquired from the Red Sox in 1921, he went on to win 157 games as the Yankees' ace, plus six more in World Series play, before being sent to Detroit in 1930. In all, he was 237-182 in 21 seasons, good enough for a berth in the Baseball Hall of Fame. "The secret of success," he once said, "is to pitch for the New York Yankees."

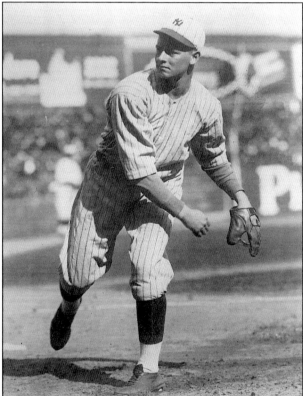

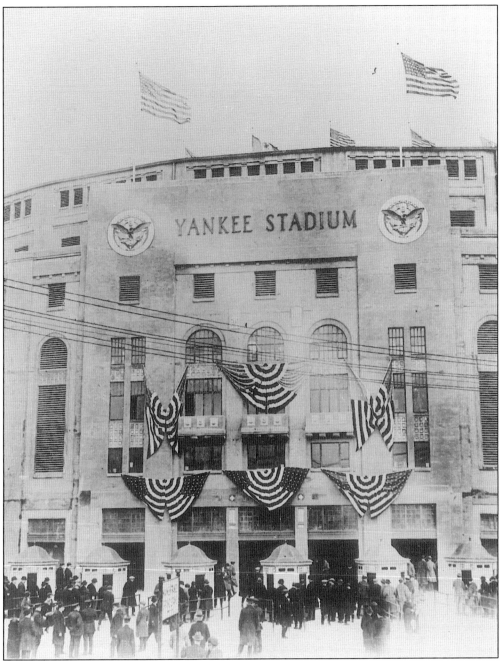

THE HOUSE THAT RUTH BUILT. After several years of sharing the Polo Grounds with their cross-town rivals, the Giants, the Yankees moved into their new home on a chilly Wednesday, April 18, 1923. The first Yankee Stadium home run was hit by Ruth, who belted a three-run homer off of Boston's Howard Ehmke in the fourth inning, giving the Yankees a 4-1 victory in their first game inside the steel-and-concrete structure.

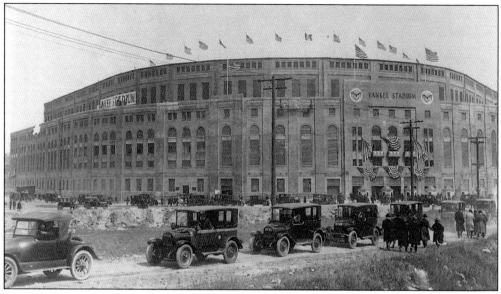

YANKEE STADIUM, 1923. Yankee Stadium was erected on a 10-acre site in the west Bronx, across the East River from the Polo Grounds. Grandstand seats cost $1 on opening day. Yankee Stadium cost $2.5 million to build and could seat 60,000, though the leniency of fire marshals sometimes allowed crowds of 70,000 and more into the park.

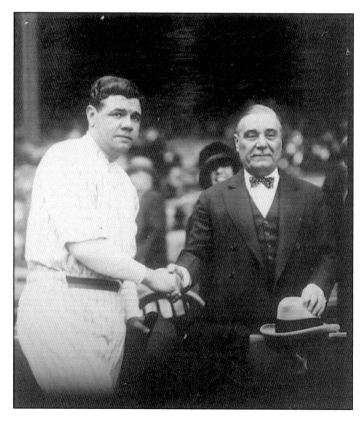

RUTH AND THE COLONEL, 1923. The man who really built Yankee Stadium was Colonel Jacob Ruppert, the New York beer baron who bought a half-interest in the team in 1915. Accustomed to winning and the finer things in life, Ruppert's money bought him Ruth and a flock of other talented players. By the time Ruppert died in early 1939 at age 72, he had seen his Bronx Bombers capture 10 pennants; more were on the way.

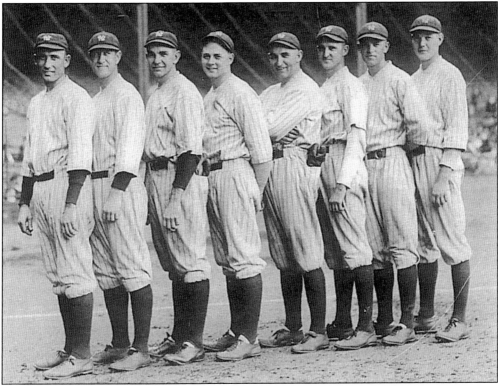

PITCHING IN. The 1923 New York mound corps topped the American League in complete games (102), strikeouts (506), and earned run average (3.66), as the Yankees won their third straight pennant. Shown here are, from left to right, Sad Sam Jones, Bullet Joe Bush, Bob Shawkey, Waite Hoyt, Carl Mays, Herb Pennock, Oscar Roettger, and George Pipgras.

HERB PENNOCK. A man who helped the Red Sox and Philadelphia Athletics capture flags, Herb Pennock pitched on five pennant winners with the Yankees starting in 1923. The Hall of Famer won 240 games overall and was a perfect 5-0 in World Series play with New York.

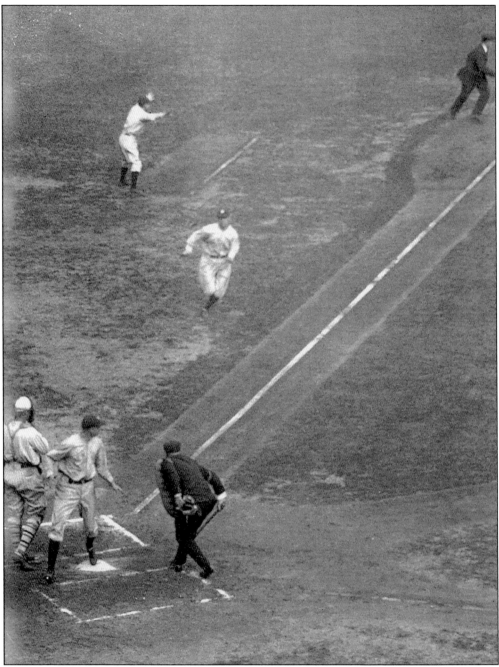

WORLD SERIES ACTION. In 1923, for the third straight October, the Yankees and Giants met in the World Series. Rounding third and hustling home in this action shot from the fourth game are Yankees Wally Pipp and second baseman Aaron Ward, both scoring on Everett Scott's single. The Yankees tallied six times in the second inning en route to an 8-4 victory.

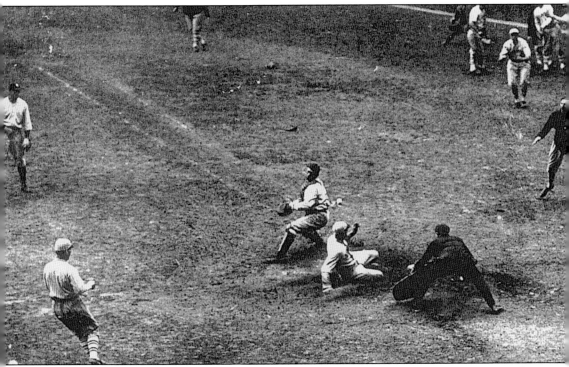

CASEY THE HERO. The ball bounces away from Yankees catcher Wally Schang as Casey Stengel legs out an inside-the-park home run to give the Giants a thrilling 5-4 victory in the opener of the 1923 World Series. Two days later, Stengel would hit another home run to sink the Yankees in game three, 1-0. Despite Stengel's heroics, the Yankees won the series in six games to celebrate their first world's championship.

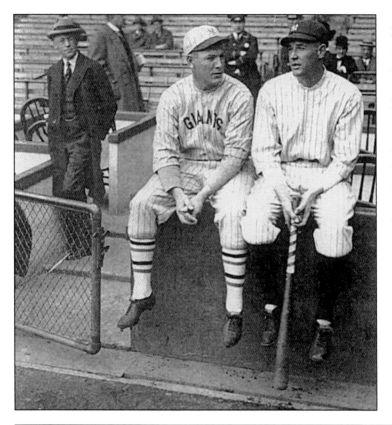

ALL IN THE FAMILY. The Meusel brothers, the Giants' Irish (left) and the Yankees' Bob (right), opposed each other in three straight World Series, 1921–23. Bob Meusel, a left fielder, was known for his long-ball hitting and powerful arm. It was said that even the great Ty Cobb would not run on Meusel. In 1925, Meusel led the league with 33 home runs and 138 RBI.

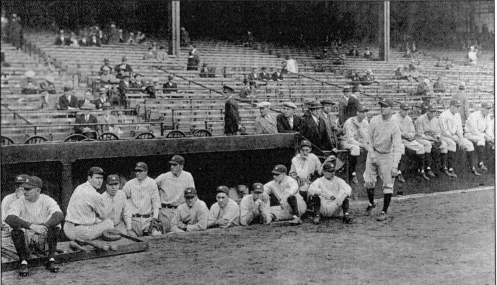

THE 1926 YANKEES. After dropping to seventh place in 1925, a season that saw Ruth miss much of the year because of injuries and suspensions, the Yankees and the Babe rebounded in fine style in 1926. Ruth just missed winning the Triple Crown, losing the batting title to Detroit's Heinie Manush on the last day of the season. Nonetheless, he hit .372 with a major-league best 47 homers and 145 RBI as the Yankees finished three games in front of Cleveland.

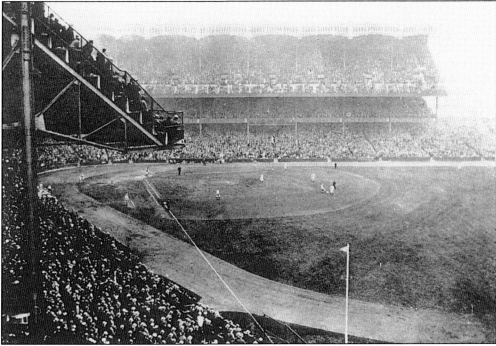

YANKEE STADIUM, 1926 WORLD SERIES. "I'll never forget what a thrill it was walking into Yankee Stadium for the first time, on the opening day of the 1926 Series," said St. Louis third baseman Les Bell. "That ball park was up for only a few years at that time but already there was a magic about it. It was big and beautiful and important looking. And of course Babe Ruth played there. Maybe that was it: Babe Ruth."

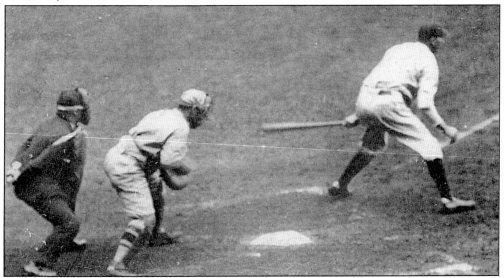

A SWING AND A MISS. With the bases loaded and two out in the bottom of the seventh inning of the seventh game of the 1926 World Series, rookie shortstop Tony Lazzeri struck out against grizzled Grover Cleveland Alexander—one of the classic confrontations in baseball history. Alexander shut down the Yankees the rest of the way to give the underdog Cardinals the championship.

19

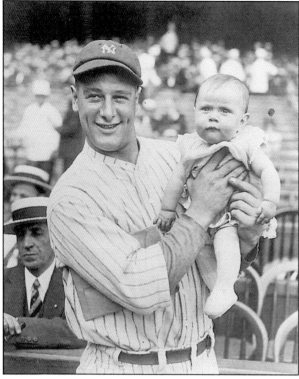

A COUPLE OF YOUNGSTERS. Lou Gehrig was only 23 years old when he posed with sportswriter Christy Walsh's child at the 1926 World Series, the first baseman's first post-season action. In 1926, Gehrig hit .313 with a league-high 20 triples, then batted .348 in the World Series. This season seemed a harbinger of greater things to come.

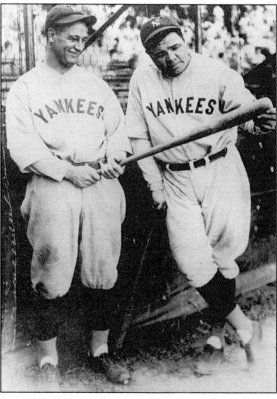

DOUBLE TROUBLE. Babe Ruth checks the barrel of Lou Gehrig's bat during the 1927 season, a summer that saw the two teammates make a run at Ruth's 1921 home run record of 59. Although a late-season power outage kept Gehrig to "only" 47 round-trippers, he won the league's Most Valuable Player Award on the strength of his .373 batting average and 175 RBI. That year Ruth made $70,000 in salary, while Gehrig was paid $7,500.

BUSTER AND BABE. Gehrig's nickname among teammates was "Buster" for the way he busted the ball, but his achievements usually were overshadowed by Ruth. "He was the one drawing the crowds," catcher Benny Bengough said of Ruth. "Even Gehrig when he was going great, he never got the publicity Babe did. See, Babe was such a colorful figure. Not just the homers, but the things he did. He was always in a jam. He was always good copy."

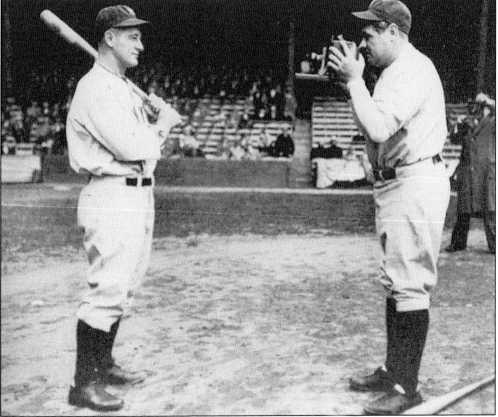

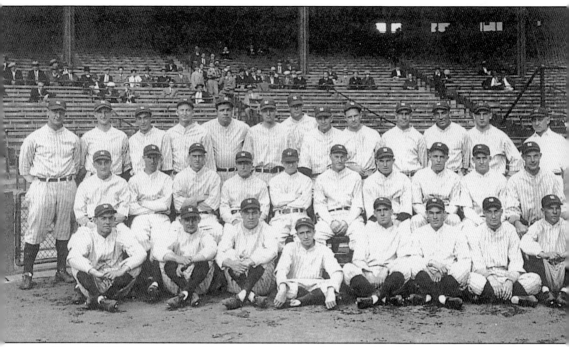

THE 1927 YANKEES. Assembled in this photograph is arguably the greatest team of all time. "Those '27 Yankees had everything," recalled pitcher George Pipgras, who accounted for 10 of the team's 110 victories. "I don't think any ball club in history could beat them. They were tops. Any team that has Ruth and Gehrig has a head start, doesn't it? They gave a pitcher confidence. You knew that if you were behind a run or two late in the game, it didn't matter; Ruth would hit one, or Gehrig would, or they both would. Then we had Earle Combs, Tony Lazzeri, Joe Dugan, Bob Meusel. Every one a great ballplayer."

NUMBER 60. On September 30, 1927, Ruth hit his 60th home run of the season against Washington's Tom Zachary. The record-breaking home run created little excitement; most fans understandably thought the Babe would just hit more the following season. As it was, the record stood 34 years.

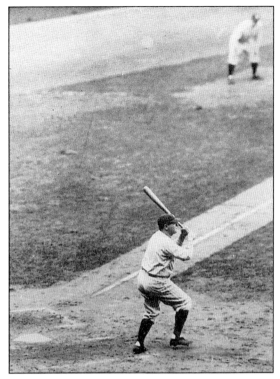

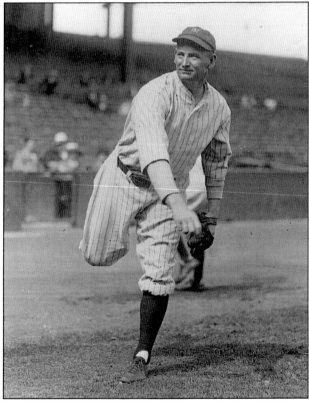

A MULE ON THE MOUND. Wilcy Moore was a 30-year-old rookie sensation in 1927, the year he won 19 games and saved 13 more. A notoriously bad hitter, he won a $300 wager with Ruth, who bet that the pitcher would not get three hits for the season. Moore used the money to buy two mules for his farm; he named one "Babe" and the other "Ruth."

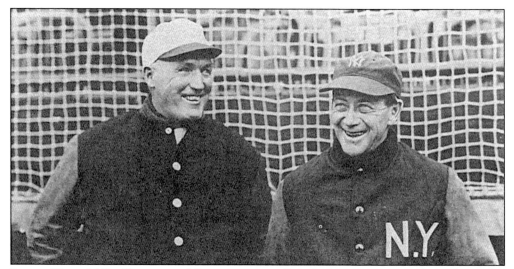

LITTLE HUG. Miller Huggins and Boston manager Rough Carrigan are seen here during the 1927 season. The diminutive New York skipper had spent 13 years as a big-league second baseman, but it was his dozen years (1918–29) riding herd on the Yankees that put him in the Hall of Fame. During his tenure, New York won six pennants and three world titles. He died unexpectedly of blood poisoning following the 1929 season, causing even Ruth—a disciplinary problem with whom Carrigan had countless run-ins—to break down at the news.

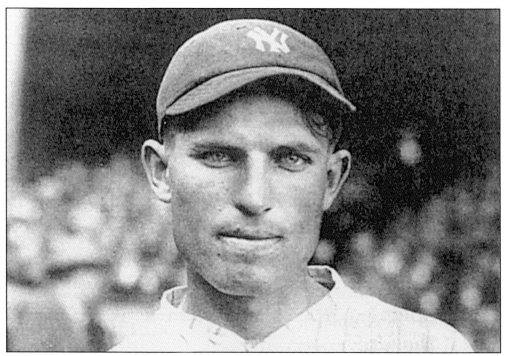

A TERROR IN '27. Mark Koenig, a free-spirited shortstop from San Francisco, hit .285 in 1927, then batted .500 in the World Series. "We just couldn't keep that fellow off the bases," lamented Pittsburgh's Lloyd Waner. "And he was batting in front of Ruth and Gehrig. That's what did us in more than anything else, that fellow always being on base when those big guys came up."

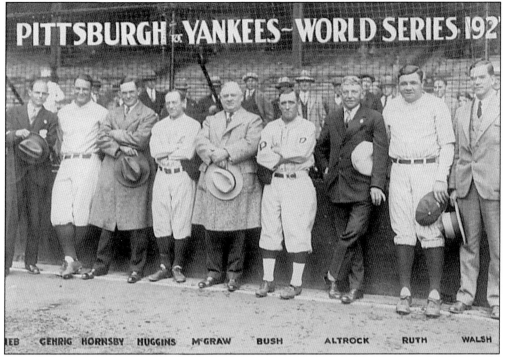

PITTSBURGH vs YANKEES~WORLD SERIES 192'

| EB | GEHRIG | HORNSBY | HUGGINS | M°GRAW | BUSH | ALTROCK | RUTH | WALSH |

THE 1927 WORLD SERIES. The 1927 fall classic proved to be anything but that for Pittsburgh, as the Yankees manhandled the Pirates in four games—the first American League sweep in World Series play.

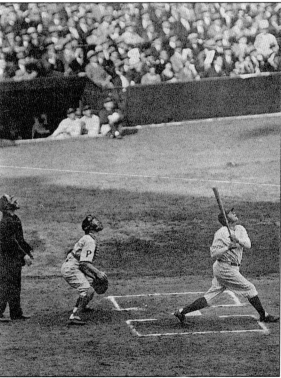

LONG GONE. All eyes were on the ball as Ruth launched one of his two World Series home runs against Pittsburgh. That winter, Pittsburgh's Waner brothers went on the vaudeville circuit. "Paul would go on the stage first and start calling into the wings asking where I was," recalled Lloyd Waner. "Finally I'd run out with a ball in my hand and say, 'I was running after the ball that Babe Ruth hit.' The audience thought that was a good one."

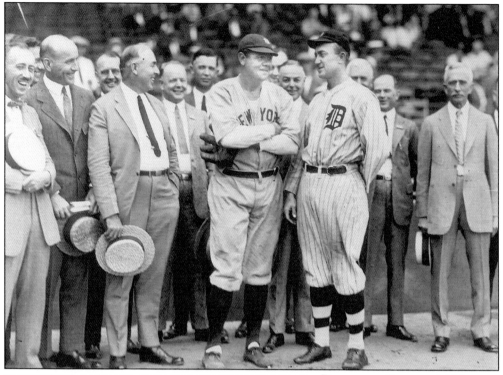

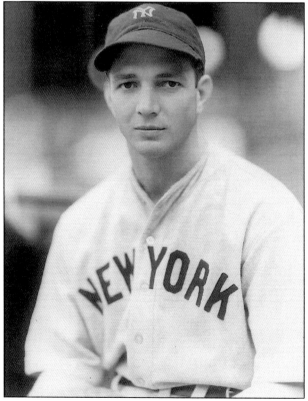

RUTH AND COBB, C. 1924. Baseball's greatest names, Babe Ruth and Ty Cobb, were not nearly as chummy as this photo suggests. Cobb, who personified the dead-ball era Ruth's home runs had made obsolete, spent his six seasons as Detroit player-manager playing second fiddle to the Yankees and their bulb-nosed basher.

TRIVIAL PURSUIT. Hank Johnson twice won as many as 14 games during his seven-season stint with New York, but he is best known as the answer to a trivia question: Who was the last man to pitch to Ty Cobb? On September 11, 1928, at Yankee Stadium, Johnson retired Cobb on a pop-up to Mark Koenig, closing out the Georgia Peach's 24-year career.

A SHOCKING END. Urban Shocker began his career with the Yankees in 1916 but became a steady 20-game winner after being dealt to the St. Louis Browns. Re-acquired in 1925, the spitball specialist went on to post a 49-29 record for the Yanks before becoming ill at the start of the 1928 season. Before the summer was through he was dead of heart disease; he was only 37.

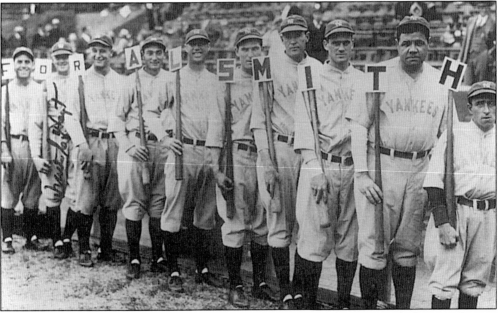

ALL FOR AL. During the 1928 season, various Yankees demonstrated their preference for Democratic presidential candidate Al Smith. At the front of the line, holding the letter H, is longtime bat boy Eddie Bennett. Smith lost the election, but the Yankees won another pennant.

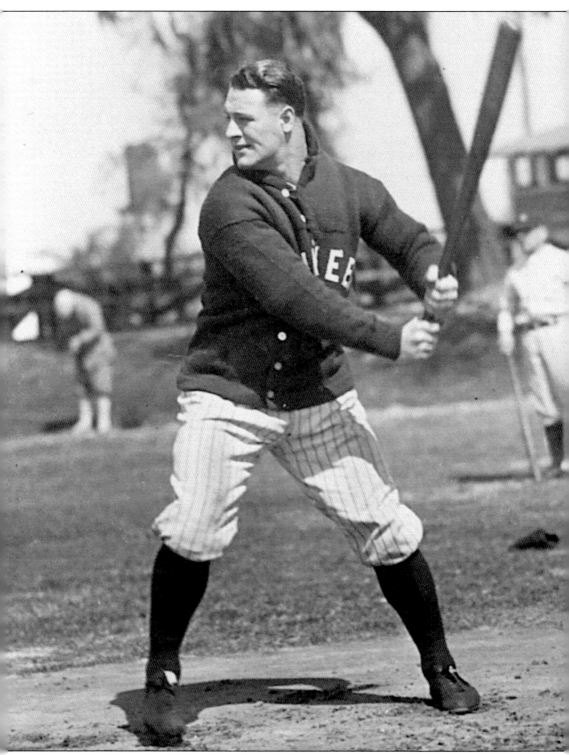

LOU GEHRIG, C. 1928. Shown is the Yankees' Iron Horse in spring training during his prime. "When that guy came to bat," said Washington's Bucky Harris, "all you could do was hold your

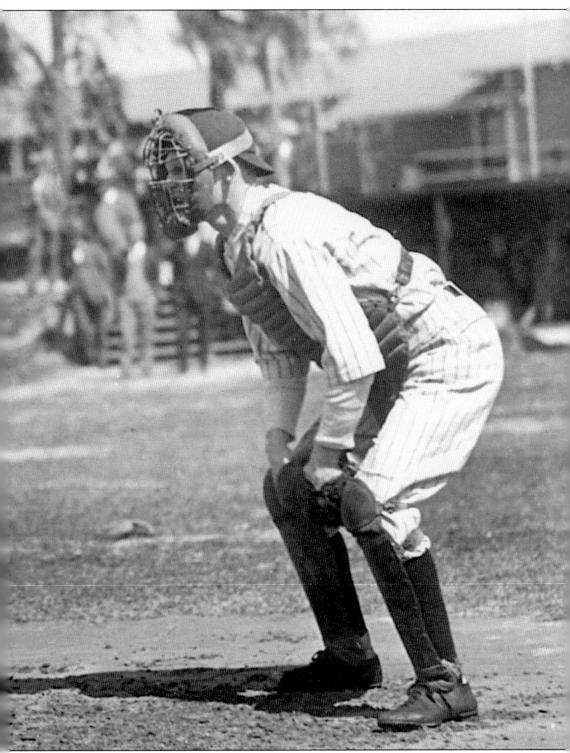

breath. When you consider everything, the number of games he played, the way he hit, his reliability and his drive, he was, for me, the greatest first baseman of all time."

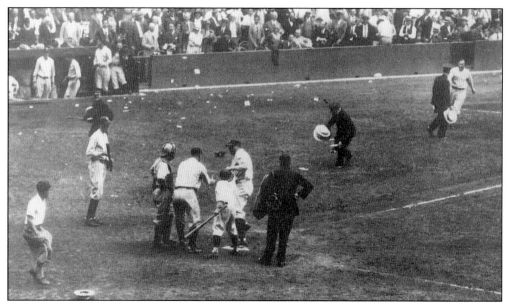

A SECOND STRAIGHT SWEEP. Straw boaters came sailing out of the stands as Ruth completed his third home run trot of the afternoon in the final game of the 1928 World Series against the Cardinals. The Yankees made short work of St. Louis, winning in the minimum four games as Ruth and Gehrig combined for seven home runs and 13 RBI and hit a collective .593.

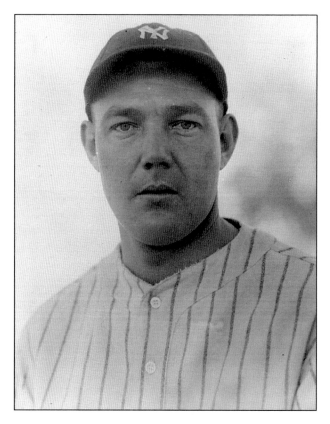

FROM PITCHER TO UMPIRE. George Pipgras led the American League with 24 victories in 1928, then beat St. Louis, 9-3, in the second game of the World Series. Pipgras won 93 games for New York between 1923 and his 1933 mid-season trade to the Red Sox. He also was victorious in all three World Series starts. After an arm injury ended his career in 1935, he became an American League umpire for many years.

BOB SHAWKEY IN 1930. After Miller Huggins's unexpected death in 1929, the Yankees hired Bob Shawkey to manage. Shawkey had pitched 13 seasons with the team, winning 20 or more games four times. He was a bust on the bench, though, unwilling to discipline old friends like Ruth. He guided the team to a third-place finish, then was let go in favor of veteran National League manager Joe McCarthy.

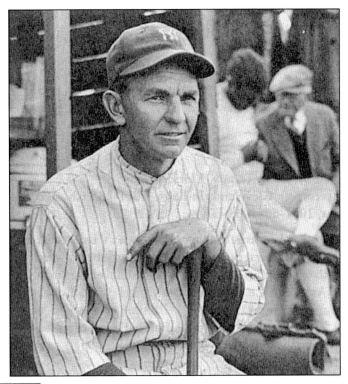

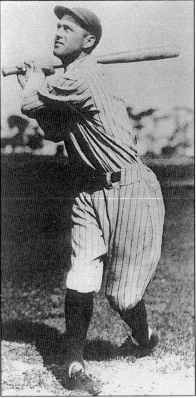

EARLE COMBS. Between 1924 and 1935, the set-up man for Murderers' Row was center fielder and lead-off man Earle Combs. A .325 lifetime hitter blessed with speed and grit, the "Kentucky Colonel" was one of the game's true gentlemen, eschewing tobacco, alcohol, and foul language. When he was named to the Hall of Fame in 1970, he responded, "It was the last thing I expected. I thought the Hall of Fame was for superstars, not average players like me."

WARMING UP. It was always great to be young and a Yankee. From left to right, Bob Meusel, Mark Koenig, Babe Ruth, Lou Gehrig, and Earle Combs warm up before a game at Yankee Stadium, *c.* 1928.

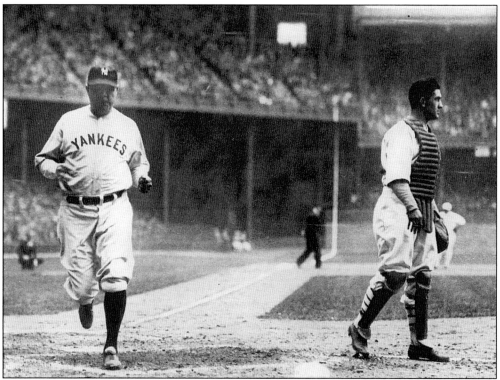

FABULOUS PHILLY. The battles between Philadelphia and New York in the late 1920s and early 1930s were hotly contested, high-scoring affairs featuring several future Hall of Famers on both sides. Here Ruth scores at Shibe Park, while Athletics catcher Mickey Cochrane glares out at his fielders. Philadelphia won three straight pennants, 1929–31, and finished second to New York in 1927, 1928, and 1932.

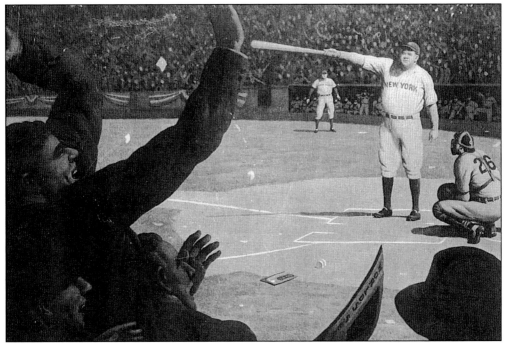

THE CALLED SHOT. The 1932 World Series was Babe Ruth's last, and he characteristically went out in a burst of headlines. According to baseball lore, in the third game against the Chicago Cubs, Ruth pointed to the bleachers at Wrigley Field before depositing Charlie Root's next pitch exactly in that spot. *Above:* This is an artist's rendition of the Babe's "called shot." *Below:* Gehrig greets Ruth at the plate after making good on his improbable boast. Did he or did he not call his shot? The question will never be answered to everybody's satisfaction. In the end, it did not matter much to the Cubs, who were swept in four straight.

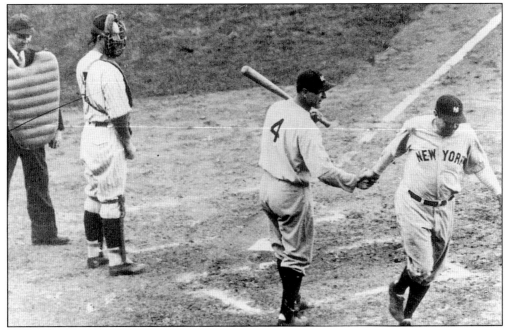

THE BAMBINO, C. 1921. A young Babe Ruth strides to the plate in the early 1920s. The familiar jowly face and beer gut had yet to materialize, but the menace in his swing was already evident to pitchers. In 1920, his first year in New York, he blasted 54 home runs, more than the combined total of 14 other teams!

Two

OH, YOU BABE RUTH!

BABE RUTH AND FRIENDS, 1922. "He was a circus, a play, a movie, all rolled into one," a teammate once said of Ruth. "Kids adored him. Men idolized him. Women loved him. There was something about him, something with men like that who come along once in a while, that made him great."

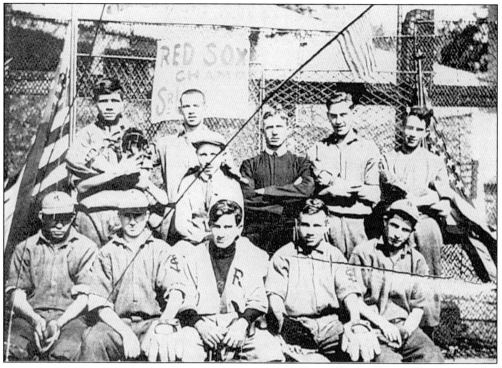

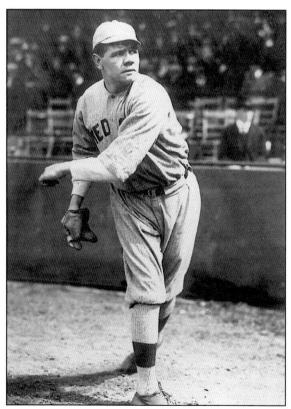

EARLY BABE. George Herman Ruth, born in 1895 to the wife of a Baltimore saloonkeeper, was a reformatory kid who found his salvation in baseball. In this picture of the team at St. Mary's Industrial School, the youngster (catching left-handed with a right-handed mitt) is standing at far left in the back row.

A MEMBER OF THE RED SOX, c. 1915. Ruth played for Baltimore's International League team before being sold to the Red Sox. During his six years with Boston, Ruth developed into the league's top southpaw and helped the Sox to three championships, compiling a dazzling 0.87 ERA in World Series play. In 1916, he led the loop with a 1.75 ERA and 9 shutouts; three years later, he smashed a record 29 homers while switching between the mound and the outfield. Ruth's all-around brilliance caused the Yankees to pay owner Harry Frazee $125,000 (plus a $350,000 loan) for his services.

RUTH IS EVERYWHERE. There was no escaping Babe Ruth during his heyday. In addition to showing up in newspapers, magazines, advertisements, and newsreels, his familiar mug graced the big screen in movies like *Babe Comes Home* and appeared on the covers of sheet music.

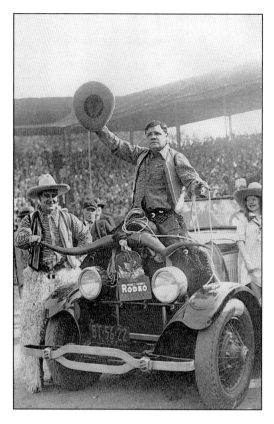

TWO COWPOKES. "Bustin' Babe" and his sidekick, "Larrupin' Lou" Gehrig, lassoed some cheers in 1928 at the World Series Rodeo inside Madison Square Garden. Despite the many photographs showing Ruth and Gehrig together off the field, the two bash brothers were never as close as the public believed. By the 1930s, they barely spoke to each other, reportedly the result of a derogatory remark Ruth made about Gehrig's mother.

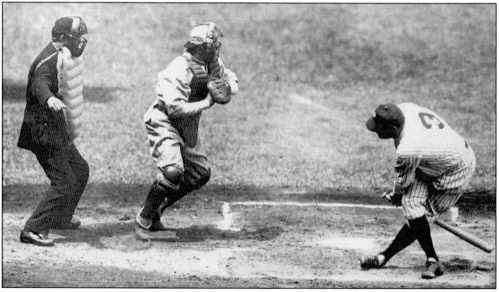

RUTH STRIKES OUT. Even the sight of Ruth striking out was worth the price of admission. "Hell, man, you were pitching to a legend!" recalled pitcher Wes Ferrell. "And you knew, too, that if he hits a home run, he's gonna get the cheers, and if he strikes out, he's still gonna get the cheers. You were nothing out there when Ruth came up."

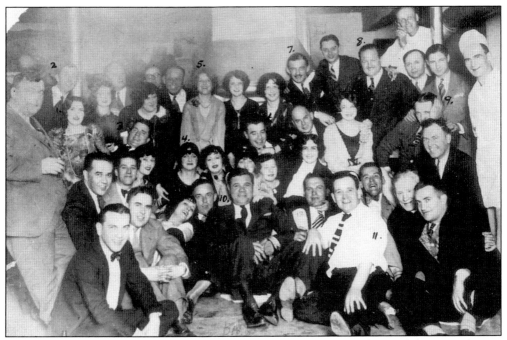

PARTY BOYS. Ruth was a welcome addition to any party, such as this Prohibition gathering at the home of Detroit contractor Alfred Tenge, *c.* 1925. Ruth is sitting in the center; to his left (with a lady's hand under his chin) is Tigers outfielder Heinie Manush. Doing his best to hide his face from the camera is another of Ruth's drinking buddies, American League batting champion Harry Heilmann, who is seated halfway up at the far right (number 9).

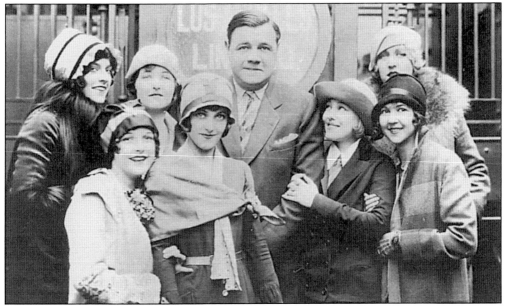

LADIES' MAN. "Ruth had telephone numbers of girls in all the big cities," recalled longtime New York sportswriter Fred Lieb, "and he knew the red-light districts of the smallest towns." Ruth was married twice and loved both his wives, wrote Lieb, "but by nature he was not a man to tie up with one woman."

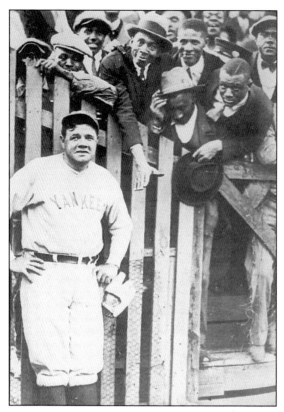

BARNSTORMING BABE. Barnstorming trips accounted for a good share of Ruth's income. People clamored to see him, said Doc Cramer. "You might have fellows today hitting more home runs than Babe Ruth, but you still don't have Babe Ruth. To me it was remarkable what a drawing card that man was. The fans—grown-ups as well as kids—would ache just to touch him."

THE FIRST MRS. RUTH. Helen Woodford was only 17 when she married Ruth in 1914, but his womanizing drove her to despair. "I guess I just don't keep up with the competition," she confided to a friend. The young couple is pictured here with Dorothy, the infant they adopted in 1921. The first Mrs. Ruth tragically died in a house fire in 1929, by which time she was the Babe's wife in name only.

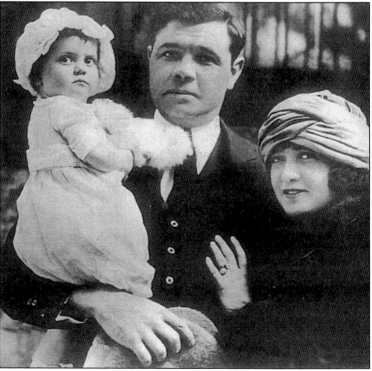

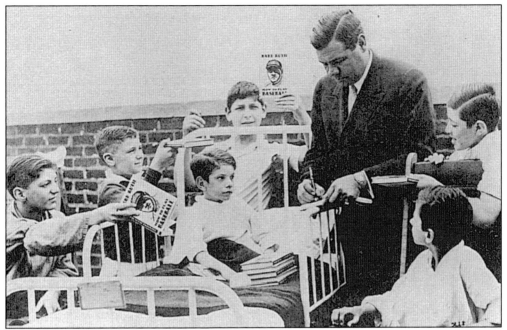

THE WRITE STUFF. Thanks to ghostwriters, Ruth "wrote" more books than he read. One thing that was genuine was his affection for children. Here he autographs copies of his latest book, *How to Play Baseball*, for kids during one of his regular hospital visits.

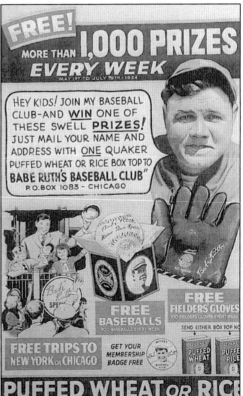

HEY KIDS! The Babe pitched countless products, including Quaker Brand cereals. This 1934 ad offered kids a free membership badge when they joined the Babe Ruth Baseball Club; their box top also put them in the running for thousands of free prizes.

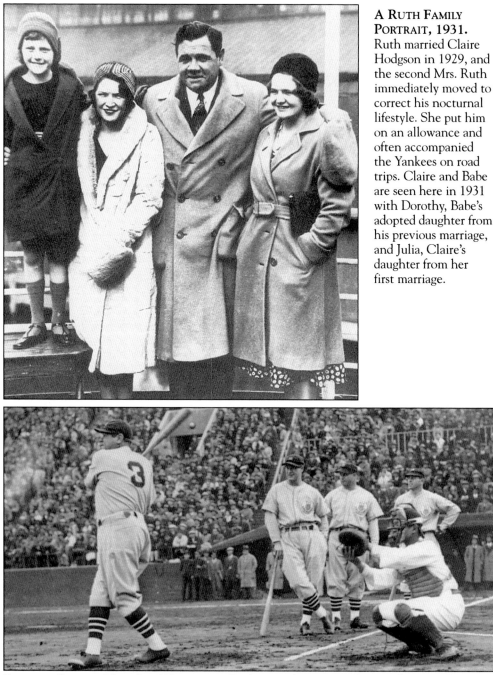

A RUTH FAMILY PORTRAIT, 1931. Ruth married Claire Hodgson in 1929, and the second Mrs. Ruth immediately moved to correct his nocturnal lifestyle. She put him on an allowance and often accompanied the Yankees on road trips. Claire and Babe are seen here in 1931 with Dorothy, Babe's adopted daughter from his previous marriage, and Julia, Claire's daughter from her first marriage.

RUTH IN JAPAN. After the 1934 season, Ruth joined a group of major leaguers for a tour of Japan. Here Lou Gehrig, Jimmie Foxx, and Earl Averill watch Ruth take his cuts at Meiji Shrine Stadium in Tokyo. When he returned, he was released from the Yankees, for whom he had long wanted to manage, and signed with the Boston Braves. At 40 years old, he batted a feeble .181 in 28 games before announcing his retirement. His six home runs as a National Leaguer gave him a final total of 714, a record that would stand until Hank Aaron broke it in 1974.

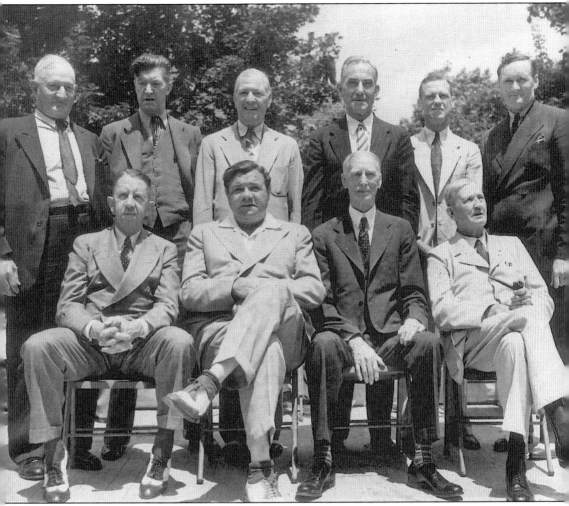

THE CLASS OF 1939. The Baseball Hall of Fame opened in Cooperstown, New York, one summer day in 1939 with its first class of inductees. From left to right, they are as follows: (seated) Eddie Collins, Ruth, Connie Mack, and Cy Young; (standing) Honus Wagner, Grover Cleveland Alexander, Tris Speaker, Napoleon Lajoie, George Sisler, and Walter Johnson. Missing is Ty Cobb, the only inductee to gather more votes than Ruth.

Two Old Foes. During World War II, Ruth participated in charity golf and baseball exhibitions with an older, more mellow Ty Cobb.

LEAVING THE GOOD STUFF OUT. Ruth, dying of throat cancer (but still with a cigar in hand), presents the manuscript of his autobiography to Yale first baseman and captain, George Bush, in June 1948. Ruth gave the future president a wink and said, "You know I couldn't put everything in a book like this."

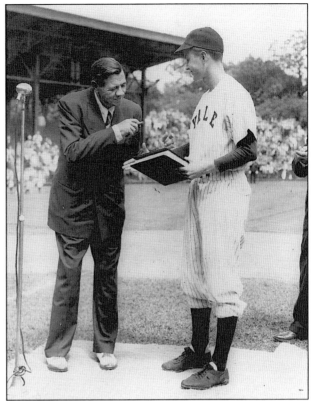

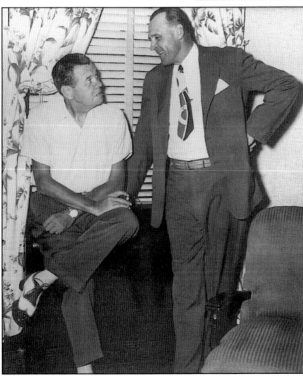

DOUBLE BIG LEAGUERS. Eddie Wells pitched several seasons in Detroit before joining New York in 1929. "Man, we were always in awe when we met the Yankees," recalled Wells, seen here inside his Alabama home with his dying idol. "There was just a certain air about them, like they were different from other ball clubs. We looked at them as being double big leaguers."

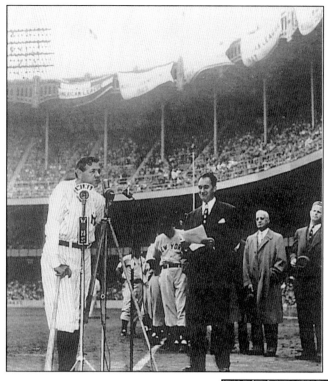

RISING TO THE OCCASION.
On June 13, 1948, Ruth participated in ceremonies marking the 25th anniversary of Yankee Stadium. That afternoon, his famous number 3 was retired, his locker sealed, and he wore his pinstriped uniform for the last time. His once powerful body wasted to nothing by cancer, Babe used Cleveland pitcher Bob Feller's bat as a cane and hobbled out to acknowledge the cheers. "He always tried to raise to the occasion," remembered his daughter Julia, "no matter how badly he felt." Two months later, he was dead.

GOODBYE, BABE. Ruth died on August 16, 1948. His body laid in state at the main entrance to Yankee Stadium for two days; hundreds of thousands of people stood in line for hours in order to pay their last respects.

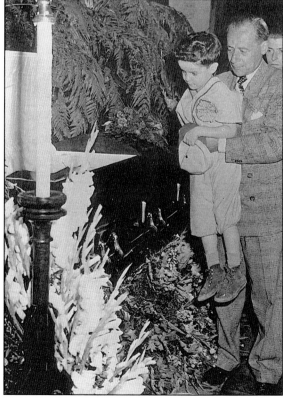

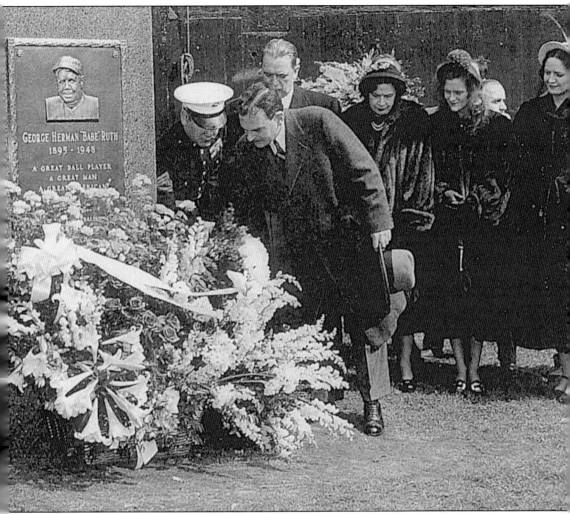

A Monumental Memory. New York Governor Thomas E. Dewey placed a memorial wreath at Ruth's monument at Yankee Stadium. Generations of fans grew up believing Ruth was buried in deep center field. Actually, he rests at Gate of Heaven Cemetery in Hawthorne, New York, with Claire Ruth, who passed away in 1976.

GOOFY GOMEZ. Vernon "Goofy" Gomez, the man who said he owed his success to "clean living and a fast outfield," earned his nickname through his wit and antics. He was a serious customer on the mound, though. Gomez, also known as "Lefty," won 189 and lost 101 during his 13 seasons in New York. The lanky Californian led the loop in wins and ERA twice each and in strikeouts three times. With Gomez winning six World Series games without a loss, the Yankees captured five championships in the 1930s.

Three

BRONX BOMBERS

THE CROW. Shortstop Frank Crosetti, shown here before the start of the 1938 World Series at Wrigley Field, was only a .245 career hitter, but he cashed more post-season checks than anybody in history. Crosetti wore Yankees pinstripes for 37 seasons as a player and a coach and participated in 22 World Series.

LARY'S GAFFE. Lyn Lary had his finest of six seasons in pinstripes in 1931, knocking in 107 runs for the third-place Yankees. That season, the lanky shortstop inadvertently settled the home run race when, standing on first base during a game at Washington, he mistakenly thought a drive into the stands by Lou Gehrig had been caught. Actually, the ball had been hit so hard that it ricocheted into the hands of the center fielder. Lary trotted into the dugout and was called out for passing Gehrig on the bases. The gaffe cost Gehrig his first outright home run title, as he and Ruth wound up with 46 each.

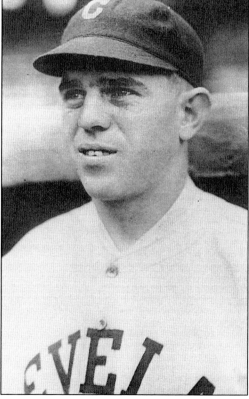

LITTLE JOE. Joe Sewell, who spent 11 illustrious seasons as Cleveland's shortstop after replacing the fatally injured Ray Chapman in the lineup, came to the Yankees in a 1931 trade. The little Alabaman played third base his three seasons in New York, quietly helping the club to a world championship in 1932. The future Hall of Famer swung a 40-ounce bat and was almost impossible to strike out; in 1,511 Yankee at-bats, he fanned a mere 15 times.

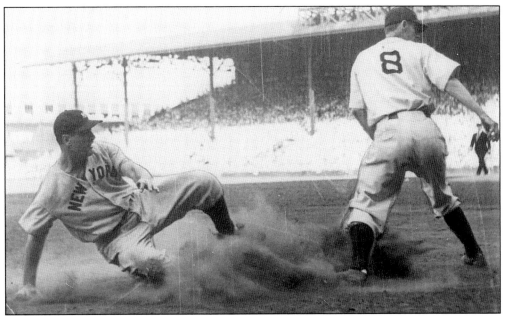

SAFE AT THIRD. Lou Gehrig slid into third base during a 1934 game at Detroit's Navin Field, while Tigers' third baseman Marv Owen awaited the throw. Although Gehrig won the Triple Crown with a .363 average, 49 home runs and 165 RBI, Detroit catcher-manager Mickey Cochrane was voted the league's Most Valuable Player.

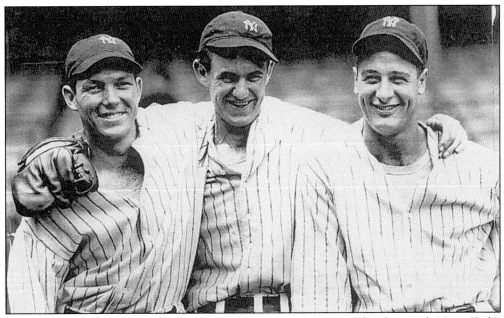

THREE FUTURE HALL OF FAMERS. While Detroit temporarily disrupted New York's dynasty with pennants in 1934 and 1935, the second-place Yankees continued to feature standout performances from catcher Bill Dickey (left), Lefty Gomez (center), and Lou Gehrig. In 1934, Gomez compiled a 26-5 record and led the loop with a 2.33 earned run average and 158 strikeouts.

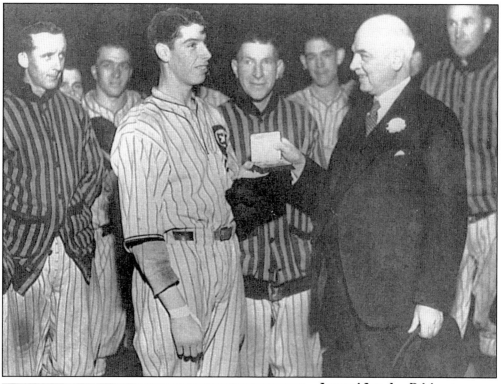

JOLTIN' JOE. Joe DiMaggio was a sensation even before taking over the center field job at Yankee Stadium. Today, few remember that the author of the famous 56-game hitting streak had enjoyed an even longer one in his first professional season. He batted safely in 61 consecutive games with the San Francisco Seals in 1933 to shatter the Pacific Coast League record. Here, San Francisco Mayor Angelo Rossi presents native son DiMaggio with a watch commemorating his feat.

GETTING THE WORD. In November 1934, Joe DiMaggio, at home peeling potatoes, just learned that he became Yankees' property. The price was $25,000.

THE OLD BALLYHOO.
This cartoon from 1935 warned of the danger of touting DiMaggio as Babe Ruth's replacement. DiMaggio batted .398 in 1935, his last season in the Pacific Coast League, then helped lead the Yankees to championships his first four seasons in New York, 1936–1939.

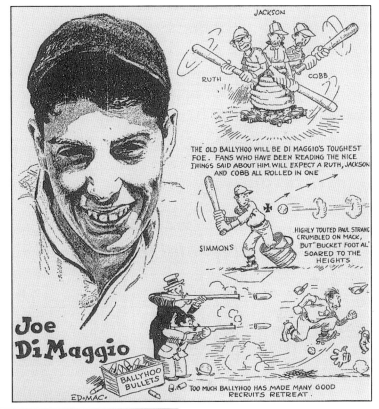

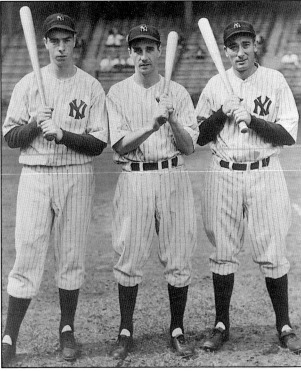

"POOSH 'EM UP" TONY.
DiMaggio joined a regular lineup that included two fellow Italian-Americans from San Francisco—shortstop Frank Crosetti (center) and second baseman Tony Lazzeri (right). Lazzeri was a force in the Pacific Coast League before joining the Yankees. In his last minor league season, 1925, he smacked 60 home runs, causing Italian fans to plead, in their heavily accented English, for Lazzeri to "poosh 'em up" at bat. An epileptic, Lazzeri died in 1946 after a seizure caused a fatal fall inside his San Francisco home.

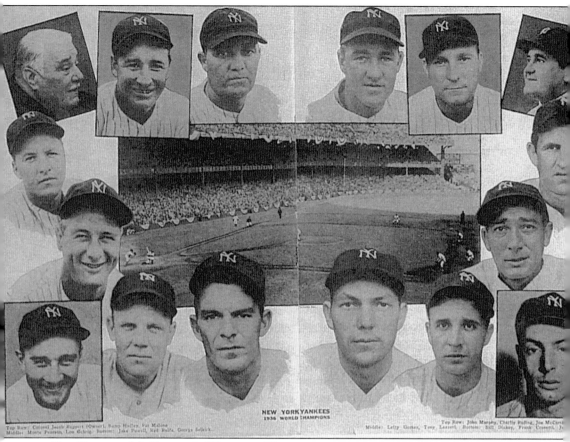

NEW YORK YANKEES
1936 WORLD CHAMPIONS

Top Row: Colonel Jacob Ruppert (Owner), Hank Hadley, Pat Malone.
Middle: Monte Pearson, Lou Gehrig. Bottom: Jake Powell, Red Rolfe, George Selkirk.

Top Row: John Murphy, Charlie Ruffing, Joe McCarthy.
Middle: Lefty Gomez, Tony Lazzeri. Bottom: Bill Dickey, Frank Crosetti, Jr.

THE FIRST OF MCCARTHY'S WINNERS. This composite photograph shows the 1936 Yankees, the first of a record four straight championship teams managed by Joe McCarthy (top right). McCarthy, dubbed "Second-place Joe" by the press because of the Yankees' runner-up position in the 1931 and 1933-35 pennant races, would wind up winning eight pennants and seven world championships with the Yankees before moving on to the Boston Red Sox. McCarthy was a disciplinarian and demanded proper behavior and dress from his players off the field. Said Goofy Gomez: "He thought playing for the Yankees called for being the same kind of gentleman who would work in a bank."

A YOUNG "OL' RELIABLE." Rookie outfielder Tommy Henrich is shown in this 1937 photograph. "The atmosphere in that clubhouse was absolutely that of nine guys getting ready to go out and play ball," he recalled. "I said to myself, 'Boy, are these guys pros.'" Henrich delivered so many clutch hits during his 11 years in New York he was dubbed "Ol' Reliable."

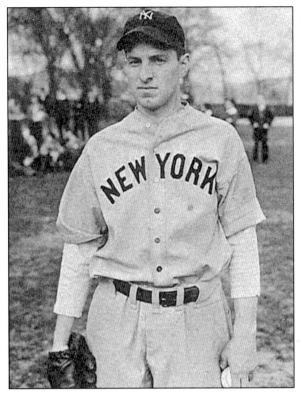

JAKE POWELL, C. 1938. Outfielder Jake Powell, who caused a stir with some bigoted remarks over the radio, was an exception to that indefinable aura that came to be known as "Yankee class." He was a member of four straight championship teams after coming over from Washington in 1936, batting a sparkling .455 in that October's six-game win over the Giants in the World Series.

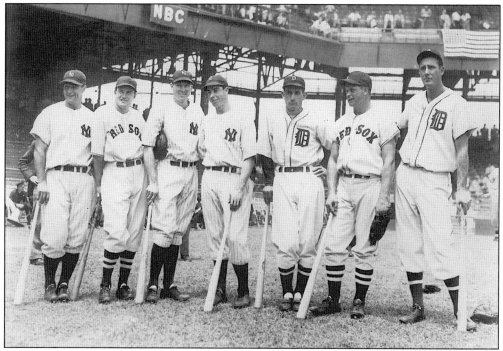

ALL-STAR BOMBERS. The Bronx Bombers were well represented in the 1937 All-Star Game, held July 7, in Washington and won by the American League, 8-3. From left to right, are Lou Gehrig (who hit a home run and had four RBI in the game), Joe Cronin, Bill Dickey, Joe DiMaggio, Charlie Gehringer, Jimmie Foxx, and Hank Greenberg. During the regular season, DiMaggio, Dickey, and Gehrig combined for 459 RBI, an average of 153 each.

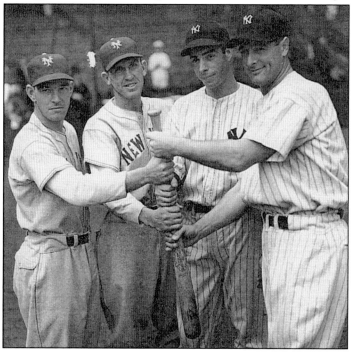

GRIP AND GRIN. The Yankees and Giants squared off in the 1936 and 1937 World Series, with the boys from the Bronx prevailing each time. Here, the Giants' Mel Ott (left) and Jo-Jo Moore grip some lumber with Joe DiMaggio and Lou Gehrig before the start of the 1937 fall classic, which featured DiMaggio's first World Series home run and Gehrig's last.

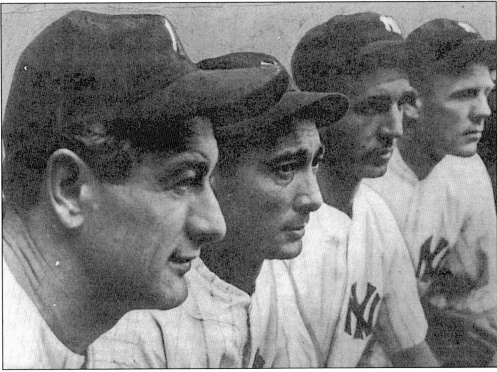

A Sparkling Quartet. Shown is the Yankees' infield in 1937, a season in which New York finished 102-52 and outdistanced second-place Detroit by 13 games. They are, from left to right, first baseman Lou Gehrig, second baseman Tony Lazzeri, shortstop Frank Crosetti, and third baseman Red Rolfe.

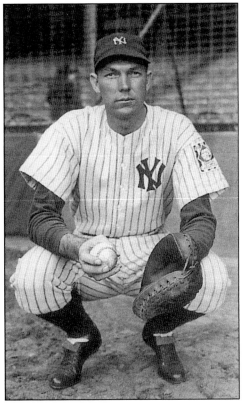

Bill Dickey in 1939. The Yankees' Rock of Gibraltar behind the plate was Bill Dickey, whose 16 seasons in New York bridged the era of the Murderers' Row teams of the 1920s and the Bronx Bombers of the 1930s and 1940s. A smooth and graceful catcher, Dickey batted as high as .362 in 1936 and .313 overall, earning him a spot in the Hall of Fame.

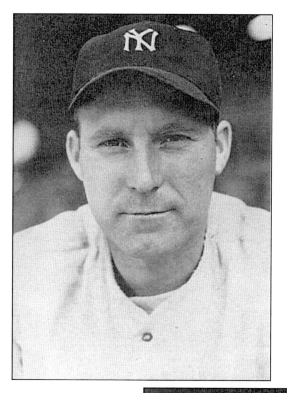

A HIT IN NEW YORK. The best hitting pitcher in big-league history may have been Charles "Red" Ruffing, whose flagging career was revived when he was traded from the lowly Red Sox to the Yankees in 1930. The future Hall of Famer won 231 games during his 15 seasons in New York, including four straight 20-win campaigns. He also was 7-2 in World Series play. A childhood accident cost Ruffing four toes on his left foot, forcing him to move from the outfield to the mound, but he never lost his hitting eye. For his career he batted .269 with 36 home runs.

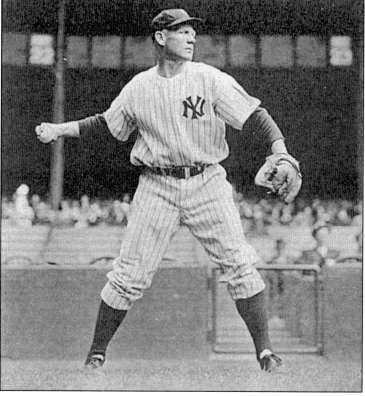

RED ROLFE. Robert "Red" Rolfe handled one ground ball as a rookie shortstop in 1931, but three years later, he was in the Yankees' lineup to stay. He anchored third base for six pennant winners, his finest season being 1939 when he led the league in hits, runs, and doubles.

GOING HOLLYWOOD. Joe DiMaggio gets the attention he is already accustomed to on the set of *Manhattan Merry-Go-Round*, a 1937 movie that resulted in the Yankees' star meeting his first wife, 19-year-old actress Dorothy Arnold. They divorced several years later.

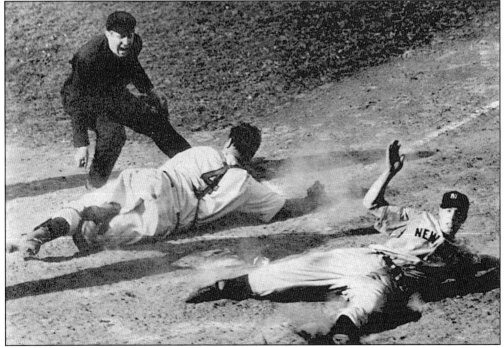

YOU SNOOZE, YOU LOSE. DiMaggio was instrumental in the Yankees' fourth straight World Series title in 1939. That summer, he led the loop in batting with a .381 average and patrolled center field with customary finesse. DiMaggio is seen here in the 10th inning of the fourth game of the World Series against Cincinnati, scoring on Ernie Lombardi's famous "snooze" after the Reds' catcher was knocked woozy by Charlie Keller, who charged home seconds earlier on DiMaggio's single. The Yanks won the game and the series.

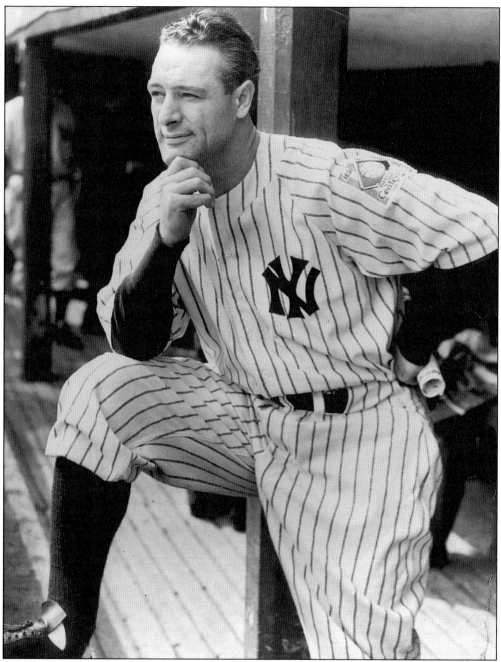

THE IRON HORSE DERAILED. Lou Gehrig stood on top of the dugout steps at Yankee Stadium in 1939, the year the Yankees captain's remarkable 2,130-game playing streak came to a halt.

Four

PRIDE OF THE YANKEES

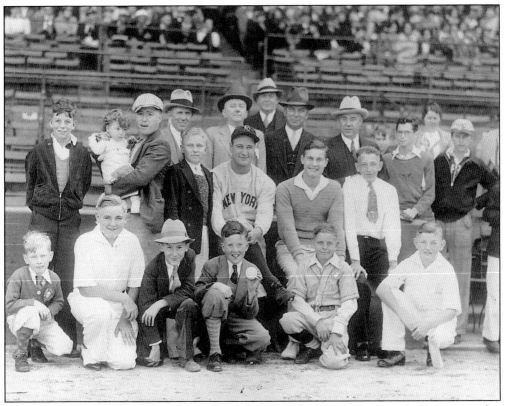

LOU AND FRIENDS. Members of the Lou Gehrig Knothole Gang pose with their namesake. According to sportswriter Stanley Frank, the Yankees' captain "was the most valuable player the Yankees ever had because he was the prime source of their greatest asset—an implicit confidence in themselves and every man on the club. Lou's pride as a big leaguer brushed off on everyone who played with him."

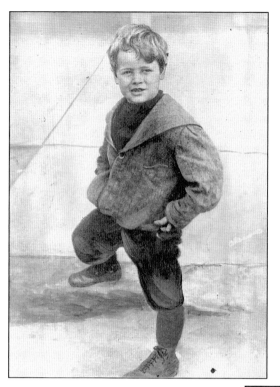

YOUNG LOU GEHRIG. The budding slugger in this pair of photographs is Louis Henry Gehrig, a heavy-legged New York schoolboy born in 1903 and destined to rewrite baseball's record book. Despite his impressive physique, Lou was not a natural athlete, noted his high school newspaper. "Gehrig, our first sacker, can certainly field," it observed, "but he is woefully weak at the plate."

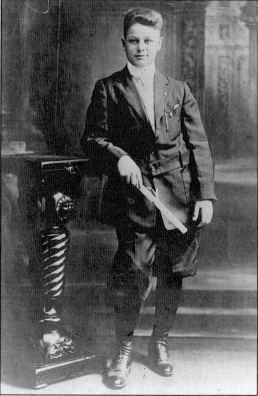

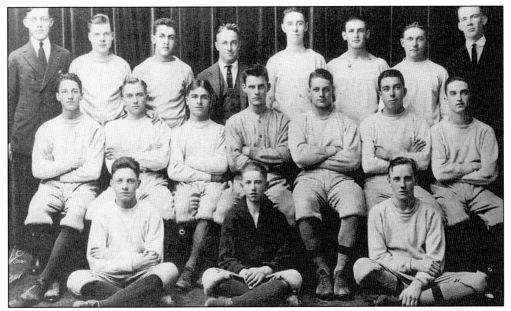

COMMERCE HIGH SCHOOL BASEBALL TEAM, 1920. Gehrig starred in football and baseball at Commerce High School, a dreary all-boys school on 65th Street that specialized in preparing students for the business world. Gehrig (third from the right in the middle row) "could hit a baseball without missing a stroke," recalled a teacher, "but his thick fingers just couldn't seem to find the right keys on the typewriter."

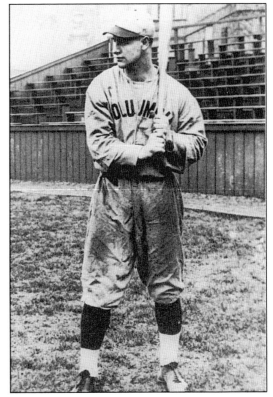

COLUMBIA LOU. Gehrig first made headlines when, at age 17, he hit a mammoth home run in a high school championship game in Chicago; however, it was a football scholarship that got him into Columbia University in 1921. He played fullback for one season and baseball for two, at which point "the best college player since George Sisler" (reported the *New York Times*) signed a $3,500 contract to play for the Yankees.

A HELPING HAND. This was no
publicity photo. Lou Gehrig, who
lived with his parents until he was 30
years old, always helped his mother
with the dishes. Momma Gehrig, who
lost three children in infancy, was
understandably overprotective of her
surviving child. Lou seemed content
at his parents' white, corner house in
New Rochelle. "You know, guys," he
told reporters more than once, "I don't
really need much else. I get everything
I want at home."

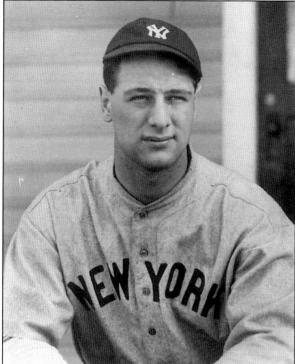

THE STREAK BEGINS. Lou Gehrig finally cracked New York's starting lineup in 1925. On June 1, he pinch-hit for shortstop Pee Wee Wanninger. The following day, he replaced Wally Pipp, who was injured in batting practice by a pitched ball, at first base. The appearances were the innocent beginning to a mighty playing streak that would not end until 14 years later.

LOU WHO? Despite occasional ads like this one, by 1928 Gehrig's identity as the unheralded half of the most devastating duo in baseball had been set. That summer was typically productive—a .374 average, 27 home runs (second in the league to Ruth), and 142 RBI (tied with Ruth). In the World Series sweep of the Cardinals, he batted .545 and knocked in a record nine runs. "Gehrig tied Ruth's record of four home runs in a series," observed the *New York Times*, "yet few knew he played."

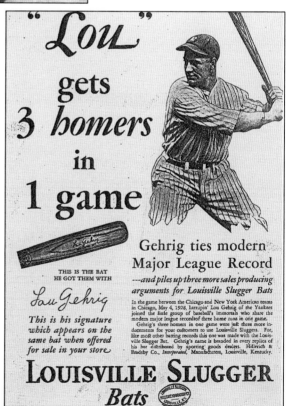

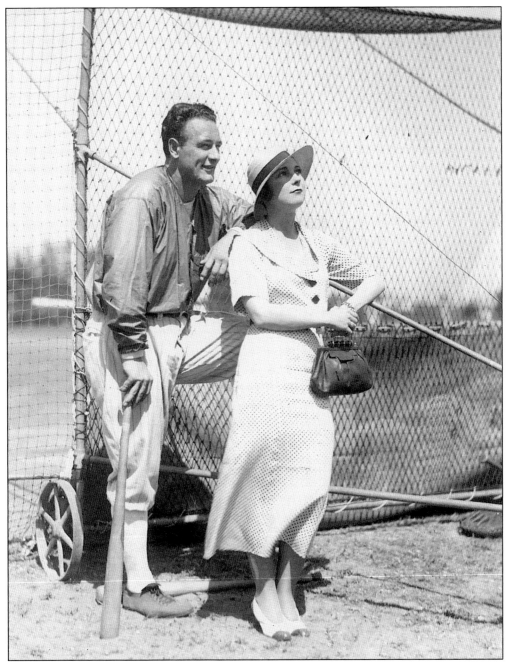

A NEW BEST GIRL. Lou conquered his bashfulness long enough to snare Eleanor Twitchell, a Chicago secretary, in 1933. The marriage came over the objections of Gehrig's old-fashioned German mother, who for years had reveled in being her only child's "best girl."

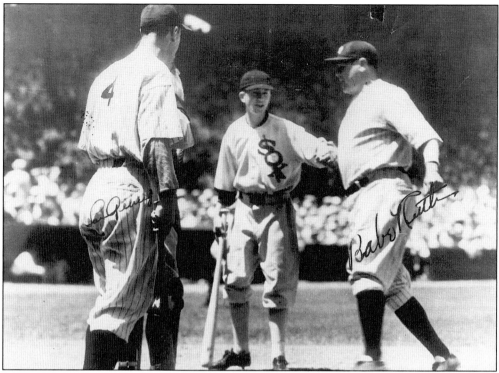

IN RUTH'S SHADOW. It was July 6, 1933, at Chicago's Comiskey Park, and Gehrig congratulated Ruth after the "Sultan of Swat" hit the first home run in All-Star Game competition. Gehrig remained good-natured about perpetually playing in Ruth's Everest-sized shadow. "If I stood on my head at the plate, nobody would pay any attention."

HIS OWN MAN. Gehrig was eventually recognized for being his own man, particularly after Ruth left the Yankees in 1934, and his iron man streak (lampooned here with a string of miniature anvils draped around his neck) continued to grow during the 1930s.

THE NEW LOU. This publicity shot of the bare-chested captain of the Yankees was the brainstorm of agent Christy Walsh, who thought the world was ready for a new Lou. To Gehrig's embarrassment, some of the beefcake photos had him posed in a loincloth with a papier-mâché club—an implied threat to Johnny Weissmuller, the reigning Hollywood Tarzan.

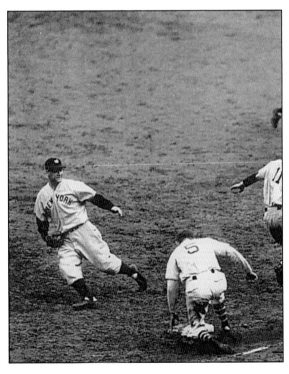

LIGHTING UP. Cigarettes were one of Gehrig's few vices, along with a passion for bridge, fishing, and cowboy movies.

LARRUPIN' LOU. Here are two Hollywood stills of Larrupin' Lou, the Bronx buckaroo. Gehrig, a huge fan of western movies, appeared in a 1938 shoot-em-up called *Rawhide* and got decent reviews for his acting. "It's fun to make a movie," he said. "But it's greater fun to hit a ball out of the stadium."

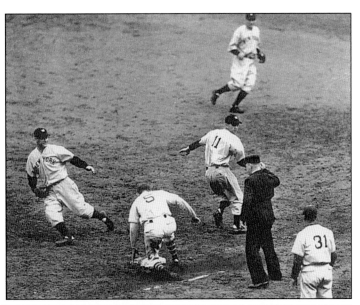

ANOTHER ONE BITES THE DUST. Gehrig takes the toss from pitcher Lefty Gomez and outraces Joe Moore to first base to record the final out of the 1937 World Series. For the second year in a row, the Yankees beat the Giants.

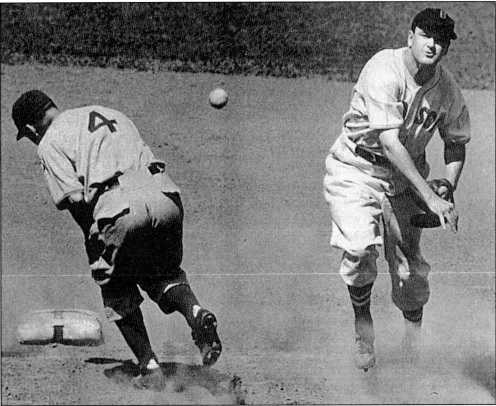

THE SILENT KILLER. By the mid-1930s, Gehrig had somehow contracted amyotrophic lateral sclerosis, an extremely rare disease that was silently but steadily destroying his nerves. The first sign that something was wrong was his sub-par 1938 season, though many observers reckoned he was simply getting old. By the start of the 1939 season, however, he was barely able to lift his legs off the ground, as evidenced by his flat-footed gait in an early season game against Boston.

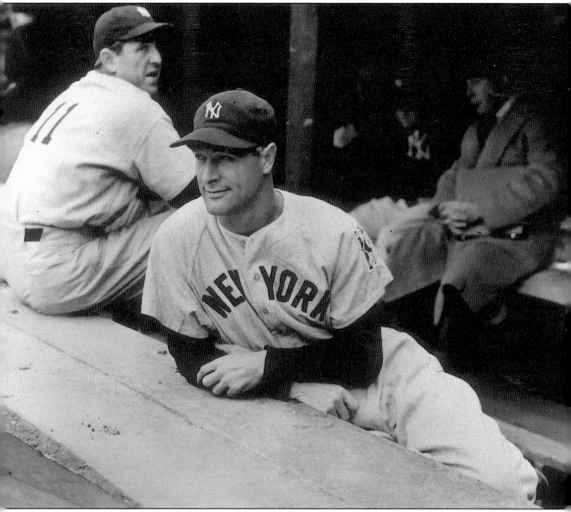

THE END OF THE LINE. Gehrig sits on the dugout steps at Briggs Stadium on May 2, 1939. That afternoon in Detroit, Lou voluntarily pulled himself out of the lineup, thus ending a career that included 493 home runs, 1,990 RBI, and a .340 batting average. Detroit fans got on their feet and gave him a two-minute ovation. A short while later, Lefty Gomez (seated to the left) told the teary-eyed Gehrig, "Hell, Lou, it took 15 years to get you out of the game. Sometimes I'm out in 15 minutes."

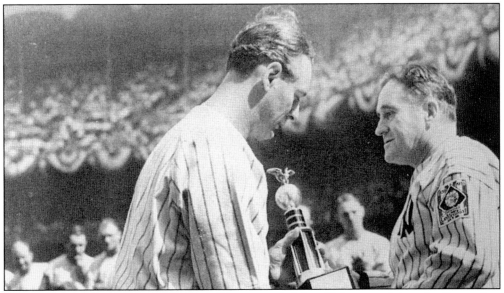

THE LUCKIEST MAN. Tests at the Mayo Clinic revealed that Gehrig was dying of a disease that had no cure. On July 4, 1939, Lou Gehrig Appreciation Day at Yankee Stadium, Lou accepted a trophy from one of his greatest admirers, manager Joe McCarthy, then grinned as Babe Ruth impulsively hugged him. In a 274-word speech that has been called baseball's Gettysburg Address, Lou bravely said, "Fans, for the past two weeks you have been reading about the bad break I got. Yet today I consider myself the luckiest man on the face of the earth."

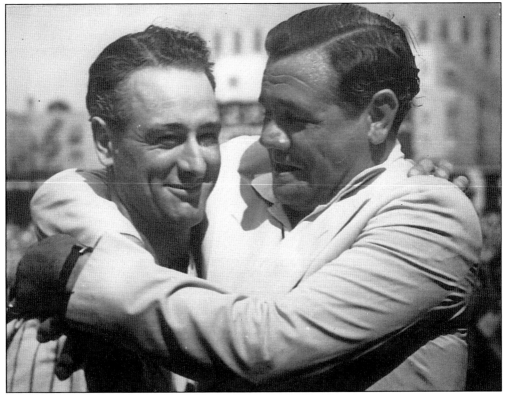

SO LONG, LOU. The body of Lou Gehrig laid in state at Christ Episcopal Church in Riverdale, New York, before being cremated. Gehrig passed away on June 2, 1941, exactly 16 years to the day that he had replaced Wally Pipp in the lineup. The coincidence was noted by many of the thousands of fans who stood in line in the rain to pay their final respects.

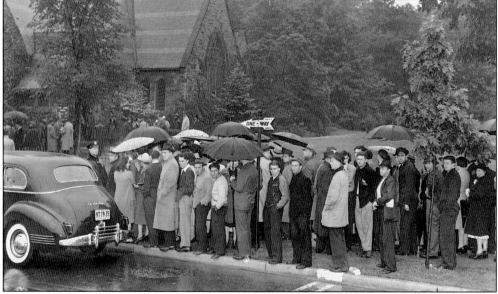

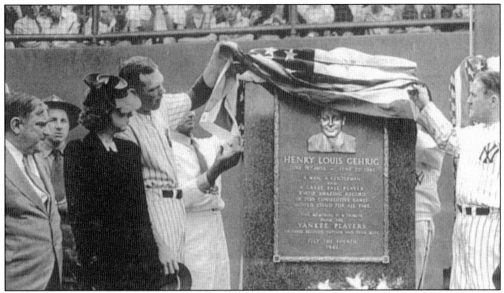

A GRANITE TRIBUTE. On July 4, 1941, less than five weeks after Gehrig's passing, Bill Dickey and Joe McCarthy helped Eleanor Gehrig unveil the monument to her late husband at Yankee Stadium. The plaque is inscribed to "A man, a gentleman and a great ballplayer. . . ."

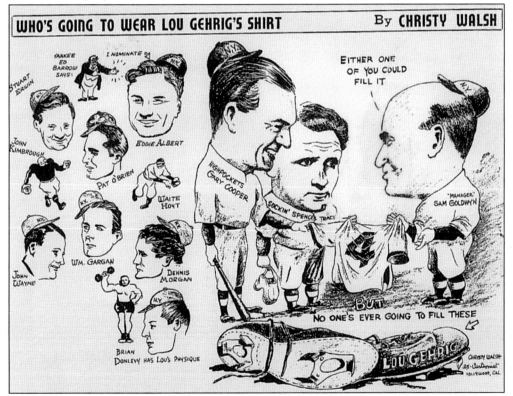

A TOUGH ACT TO FOLLOW. The Iron Horse's tragic death from amyotrophic lateral sclerosis had admirers like his agent, former cartoonist Christy Walsh, wondering who would fill his shoes.

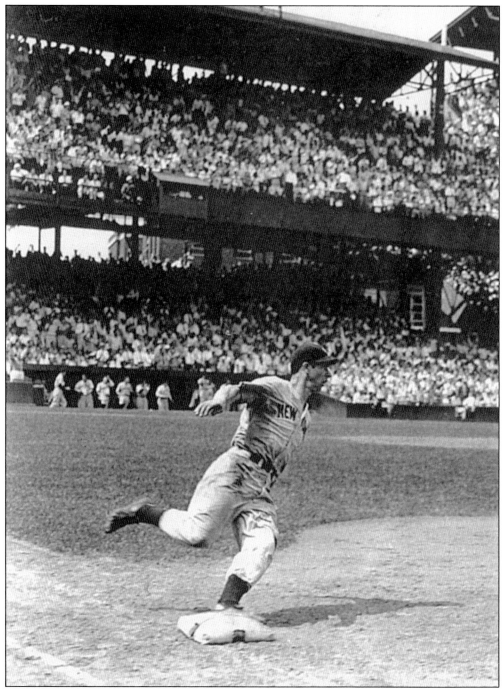

THE UNSTOPPABLE JOE DIMAGGIO. Joe DiMaggio rounded first base after hitting safely in his 42nd consecutive game in 1941. "You saw him standing out there and you knew you had a pretty damn good chance to win the baseball game," pitcher Red Ruffing said. DiMaggio, a .325 career hitter, captured two batting titles, three Most Valuable Player Awards, and had nearly as many home runs (361) as strikeouts (369). He was a member of 10 pennant winners, nine of which went on to win the World Series.

Five

NO ORDINARY JOE

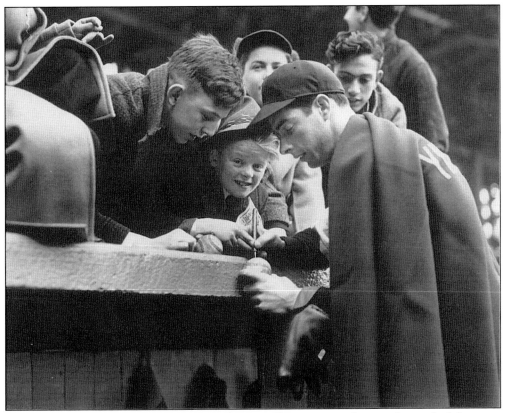

STYLE IN PINSTRIPES. Joe DiMaggio, the proudly introverted son of a crab fisherman, epitomized class during his 13 seasons in center field. The press dubbed him "The Yankee Clipper" for his effortless grace, but his bawdier teammates affectionately called him "Dago," a reference to his Italian-American upbringing in San Francisco. His most famous feat was hitting in 56 straight games in 1941, a streak that opposing teams had no compunction about advertising (following page).

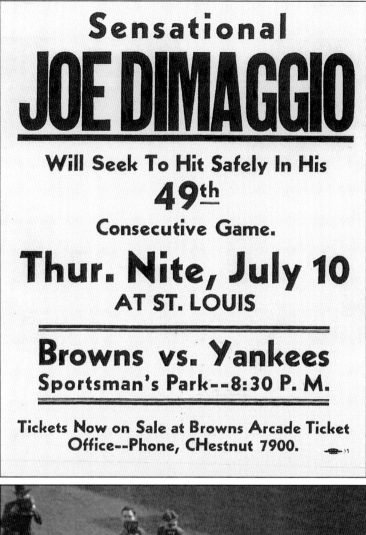

Sensational

JOE DIMAGGIO

Will Seek To Hit Safely In His

49th

Consecutive Game.

Thur. Nite, July 10
AT ST. LOUIS

Browns vs. Yankees
Sportsman's Park--8:30 P. M.

Tickets Now on Sale at Browns Arcade Ticket Office--Phone, CHestnut 7900.

THE STREAK. The eyes—and cameras—of the nation were trained on DiMaggio in the summer of 1941, as the 26-year-old made mincemeat of Wee Willie Keeler's 1897 record of hitting safely in 44 straight games. DiMaggio extended the record to 56 games before a pair of fine fielding plays by Cleveland third baseman Ken Keltner helped end the streak on July 17. The following day, the amazing DiMaggio went on another 16-game tear.

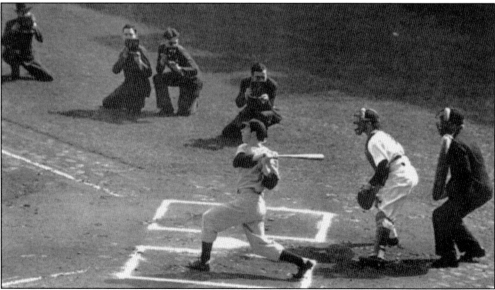

DiMAGGIO VS. FELLER. DiMaggio fouled off a Bob Feller pitch in 1941, a rare failure against the game's top pitcher. "Feller tried everything against him, high, low, inside, outside, curve, fastball," said Cleveland catcher Jim Hegan. "Nothing helped. He just hit everything Bob threw up to the plate."

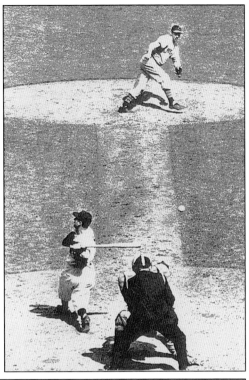

TWO LEGENDARY THUMPERS. The greatest names of 1941, Joe DiMaggio and Boston's Ted Williams, posed before a game that summer at Yankee Stadium. In 1941, Williams batted .406 and clouted the most dramatic home run in All-Star Game history, but it was DiMaggio who received the Most Valuable Player Award.

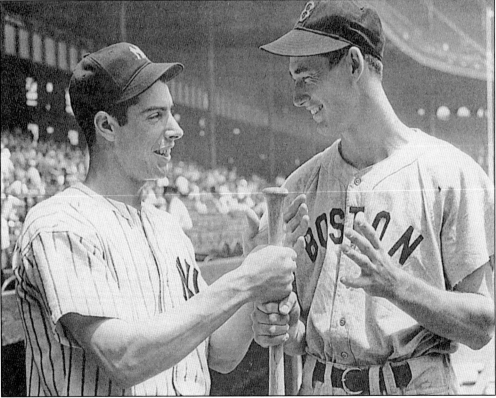

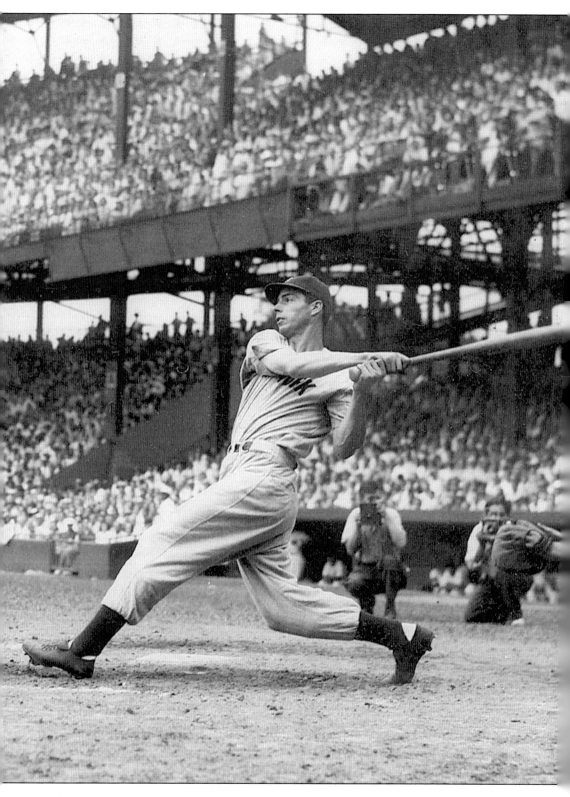

MISTAKE FREE. The classic swing of Joe DiMaggio is pictured in this photograph. "He made it look easy but he played hard," recalled his teammate, third baseman Billy Johnson. "No one compared to Joe. He was an all-around player who could hit way over .300, hit for power, run, field, throw. He didn't make mistakes. He was seldom thrown out taking an extra base. He just knew when to go and when not to. And if you needed either a single or a home run, he'd get it for you."

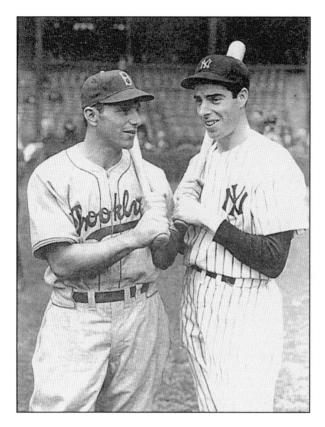

THE FIRST YANKEES-DODGERS WORLD SERIES. DiMaggio and Brooklyn's Dolf Camilli are pictured during the 1941 World Series, which the Yankees took in five games. It was the first of seven fall classics involving the two teams between 1941 and 1956.

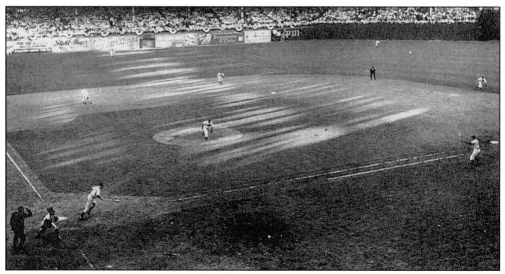

THE ONE THAT GOT AWAY. In the fourth game of the 1941 World Series, Tommy Henrich, who just struck out, raced for first base as what should have been the game-ending pitch got away from Brooklyn catcher Mickey Owen. Instead of Brooklyn tying the series at two games apiece with a 4-3 win, the Yankees scored four runs to win 7-4 and take an insurmountable 3-games-to-1 lead.

THE BREAKFAST OF CHAMPIONS. DiMaggio's dark good looks and all-around athletic excellence made him the ideal pitchman for products like Wheaties. The Yankee Clipper followed a proud tradition with this particular endorsement; a few years earlier, Lou Gehrig had been the first athlete to appear on boxes of the popular breakfast cereal.

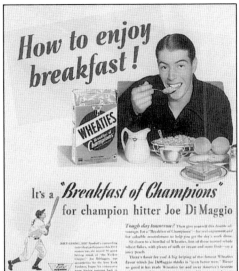

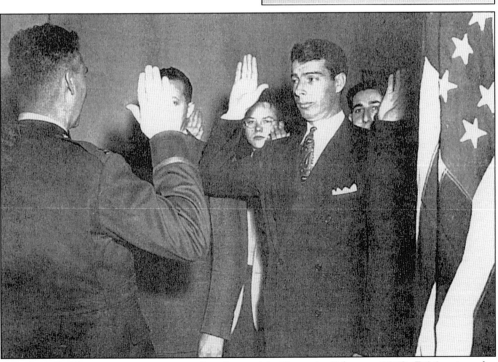

G.I. JOE. DiMaggio was sworn into the Army Air Corps in February 1943. DiMaggio, who lost three prime seasons in uniform, was just one of hundreds of major leaguers to serve during World War II. Most worked as physical training instructors and played on star-chocked service teams that often were more competitive than those in the depleted big leagues.

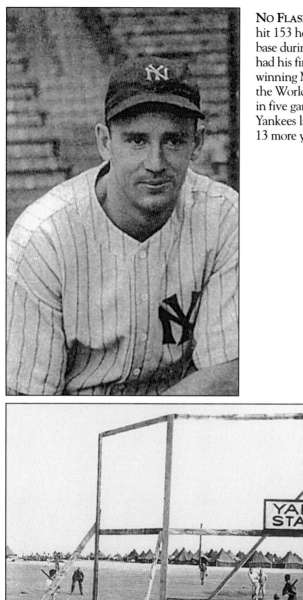

NO FLASH IN THE PAN. Joe "Flash" Gordon hit 153 homers and played a sparkling second base during his seven seasons in New York. He had his finest year in 1942, batting .322 and winning MVP honors, but could hit only .095 in the World Series as St. Louis upset the Yankees in five games. It had been 17 years since the Yankees last dropped a World Series; it would be 13 more years before they lost another.

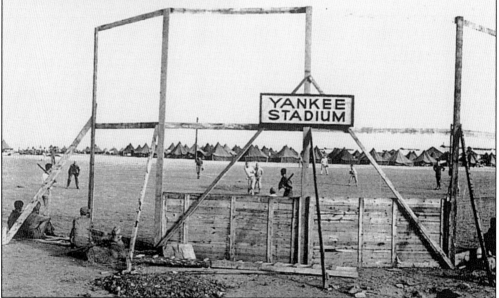

A REMINDER OF HOME. This makeshift Yankee Stadium was built by servicemen in North Africa. Fans at the real Yankee Stadium saw the home nine win two wartime pennants and the 1943 World Series against the Cardinals. During a series of war relief games in 1944, Yankee rooters also raised the most money of all 16 major league teams, contributing a gate of $34,587 to the National War Fund and American Red Cross.

SNUFFY THE MAGNIFICENT. The war gave borderline players and draft rejects a chance to play in the big leagues. Second baseman George "Snuffy" Stirnweiss made the most of his opportunity, topping the league in hits, triples, runs, and stolen bases in each of his first two full seasons, 1944–45. He also won the 1945 batting title with a paltry .309 average, the result of the major leagues using a wartime ball made of inferior materials.

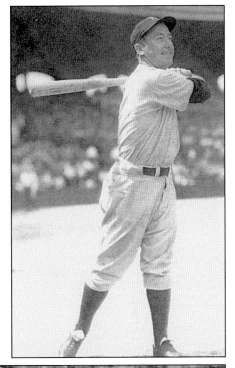

SPUD THE STUD. Spud Chandler was a 30-year-old rookie with the 1937 Yankees, but he managed to hang around past his 40th birthday. He was 20-4 with a league-low 1.64 ERA in 1943, and 20-8 in 1946. His 11-year career record was 109-43, producing a .717 winning percentage that is the highest among all pitchers with at least 150 decisions.

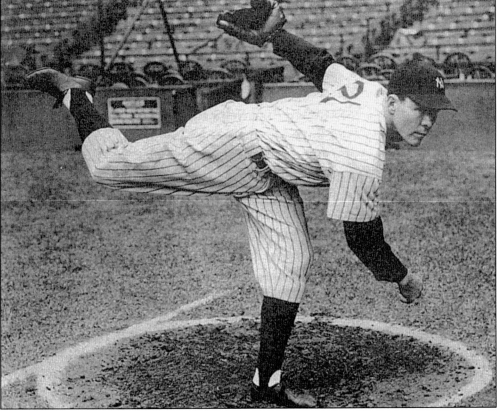

LUCKY TO BE A YANKEE. DiMaggio wrote a ghosted autobiography in 1946, the year he and hundreds of other big leaguers came home from the service. Up until his death in 1999, DiMaggio regularly turned down offers of up to $2 million to write his "real" life story.

THE DiMAGGIO BROTHERS, 1946. In addition to Joe, the DiMaggio family produced two other major league outfielders. Vince (center) was a free-swinging power hitter who played for six different National League teams between 1937 and 1946. Dominic (right) batted .298 during his 11 seasons with the Red Sox and was considered the American League's second-best defensive center fielder, behind his older brother Joe.

A COUPLE OF WINNERS. The Yankees beat Brooklyn in seven games in the 1947 World Series. Two heroes of game five were Frank Shea, who pitched the final out in the Yankees' 2-1 victory, and DiMaggio, whose fifth-inning home run provided the margin of victory.

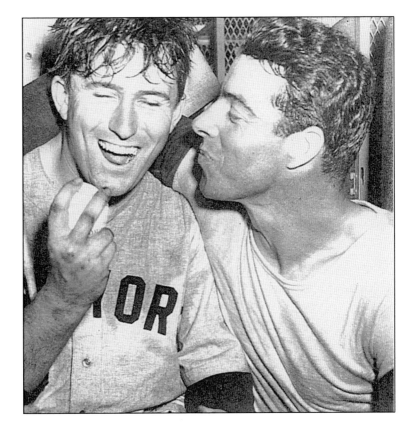

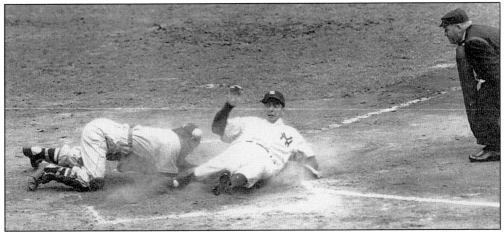

STILL THE BEST. DiMaggio's last great season was 1948, when he batted .320 and led the league with 39 homers and 155 RBI. Here, he scored in an early-season game against Washington, as the ball got away from catcher Jake Early. "Sometimes a fellow gets a little tired writing about DiMaggio," Red Smith wrote that year. "A fellow thinks, 'There must be some other ballplayer in the world worth mentioning.' But there isn't really, not worth mentioning in the same breath with DiMaggio."

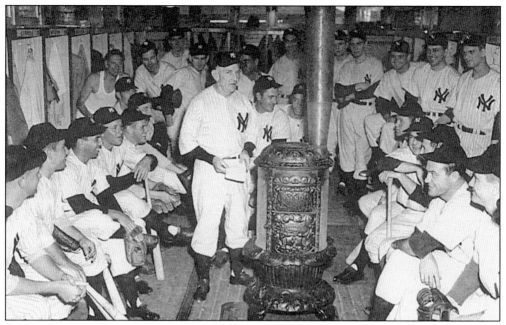

A New Skipper. Casey Stengel addressed the team at the opening of spring training in 1949. Stengel, viewed with suspicion by many reporters and players because of his reputation for clowning and history of managing second-division clubs, replaced Bucky Harris. Harris had led the team to a world championship in 1947 but was fired after finishing third in 1948.

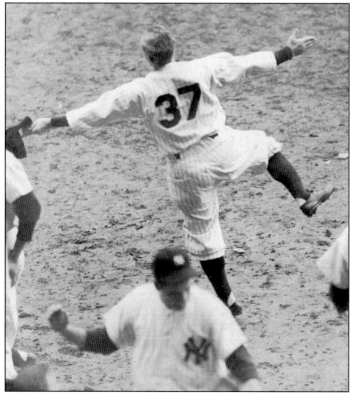

Casey Celebrates. Although he was careful to tone down his act his first season in New York, Casey could not resist a victory jig following the Yankees' 5-3 win over Boston on October 1, 1949. Beating the Red Sox the last two games of the season at Yankee Stadium gave the 59-year-old Stengel his first pennant as a manager.

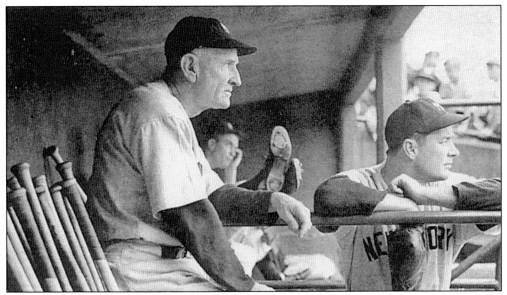

JOE PAGE, 1949. The Yankees' star fireman, Joe Page, waited out a rain delay with his manager. The burly southpaw was the premier relief pitcher of the 1940s, winning 14 games and saving 17 more in 1947. In the seventh game of that year's World Series, Page came out of the bullpen in the fifth inning and shut down the Dodgers on one hit the rest of the way to seal the Yankees' championship. During Stengel's first season at the helm, he won 13 games in relief, saved 27, and once again saved the World Series clincher against Brooklyn.

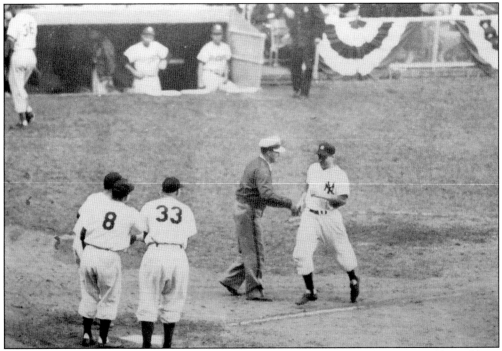

CASEY'S FIRST WORLD SERIES WIN. Tommy Henrich's ninth-inning home run off Brooklyn's Don Newcombe gave the Bronx Bombers a 1-0 victory in the opener of the 1949 World Series. The Yankees went on to beat the Dodgers in six games.

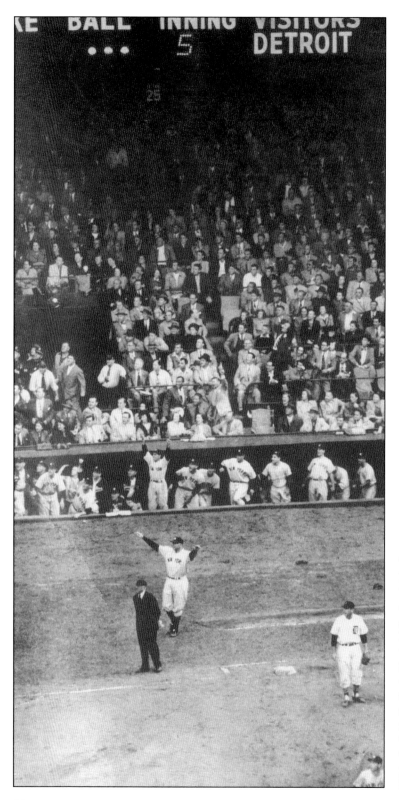

Two in a Row. Joe DiMaggio (in the lower right hand corner) looked on as Johnny Mize's home run landed in the seats at Briggs Stadium in Detroit during the 1950 season. The Yankees overtook the Tigers in the last couple of weeks to narrowly win a second straight pennant, this time by three games.

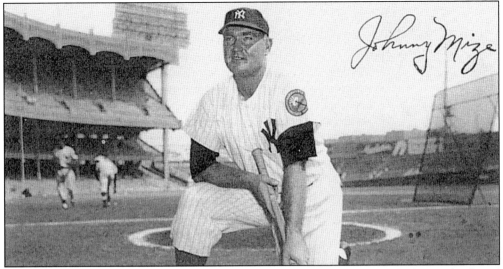

BIG JOHN. Johnny Mize, who won four National League home run titles with the Cardinals and Giants, came to the Yankees at the end of the 1949 season and made Stengel's platooning that much more effective. The Hall-of-Fame first sacker played on five straight world champions with the Yankees, finally retiring after the 1953 season with 349 career round-trippers.

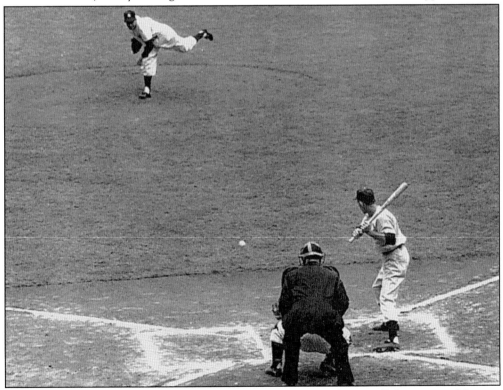

WHITEY FORD, 1950. Rookie southpaw Edward "Whitey" Ford came off the streets of Queens to win nine of ten decisions in 1950. The future Hall of Famer compiled a 236-106 record during his 16 seasons at Yankee Stadium for a dazzling .690 winning percentage. The brash, fun-loving Ford had a sneaky fastball, slow curveball, and wicked spitball.

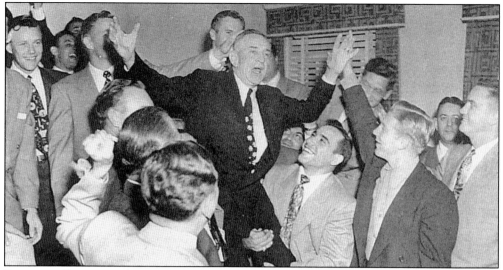

PENNANT CLINCHER. A victorious Casey Stengel was hoisted by his players (including Yogi Berra and Whitey Ford in the right foreground) upon learning that Cleveland eliminated Detroit from the 1950 pennant race, giving Stengel a second straight flag.

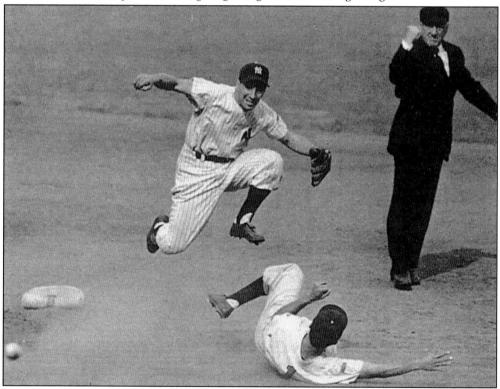

THE SCOOTER. Phil Rizzuto, a product of Brooklyn's sandlots, played a nearly flawless shortstop for 10 pennant winners in New York between 1941 and 1956, then switched to an equally memorable career in broadcasting. His best offensive year was 1950, when he batted .324 and was voted Most Valuable Player. "My best pitch is anything the batter grounds, lines, or pops in the direction of Rizzuto," claimed pitcher Vic Raschi.

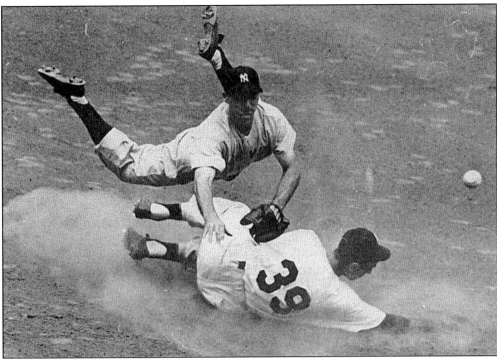

HIGH-FLYING HERO. Second baseman Jerry Coleman earned his wings as a Marine combat pilot in World War II and the Korean War, but between service stints, he solidified the Yankees' middle infield. He starred in the 1950 World Series as the Yankees beat Philadelphia's "Whiz Kids" in four straight games. Coleman drove in the only run in the series' opener, a 1-0 victory over Phillies ace reliever Jim Konstanty, a surprise starter. Coleman's ninth-inning single produced a 3-2 win in game three and earned him the series' MVP award.

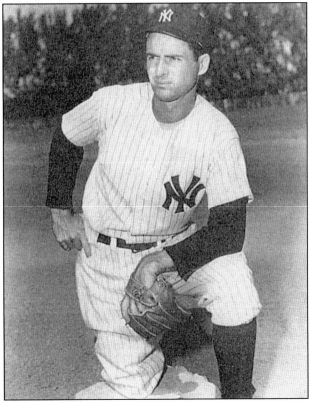

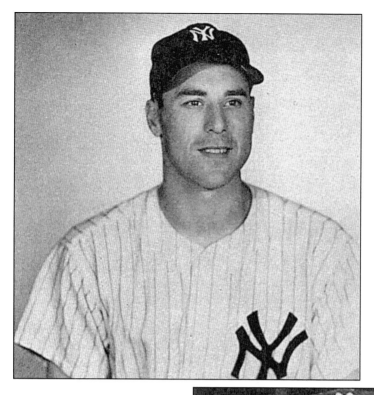

THE SPRINGFIELD RIFLE. Vic Raschi, a power pitcher from Springfield, Massachusetts, won 21 games in three straight seasons, 1949–51, and compiled an overall record of 120-50 before being traded to St. Louis before the 1954 season. Many Yankees privately believed that Raschi's departure cost them a sixth straight championship.

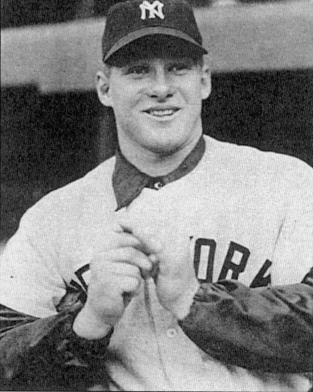

ONCE A YANKEE. The depth of the Yankees' bench was demonstrated by their 1952 trade of outfielder Jackie Jensen, who saw only limited service under Stengel's platoon system since arriving at Yankee Stadium in 1950. Jensen went on to capture three RBI titles and a stolen base crown with the Boston Red Sox during the 1950s.

TWO WAYS GREAT. Allie "Chief" Reynolds pitched for six championship teams in New York, going 7-2 with four saves and a 2.79 ERA in World Series play. "Reynolds is two ways great," said Casey Stengel, "which is starting and relieving, which no one can do like him." The versatile pitcher led the loop with seven shutouts in 1951 and six more in 1952; in each case, he saved an identical number of games to finish among the league leaders in that category. *Below:* Reynolds retires Boston's Ted Williams on September 28, 1951, to complete his second no-hitter of the season.

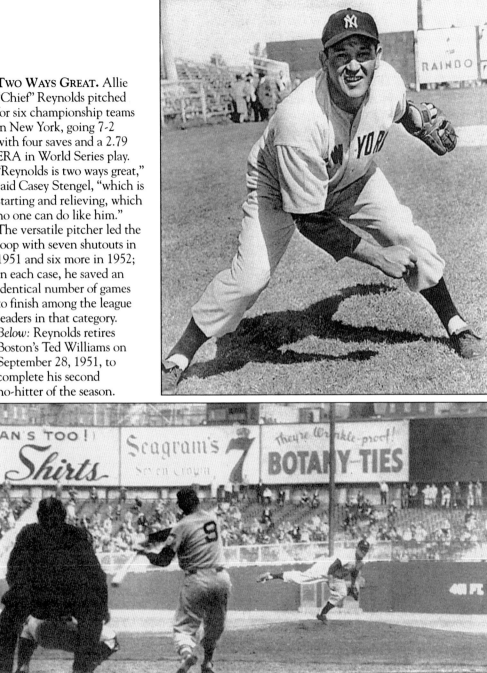

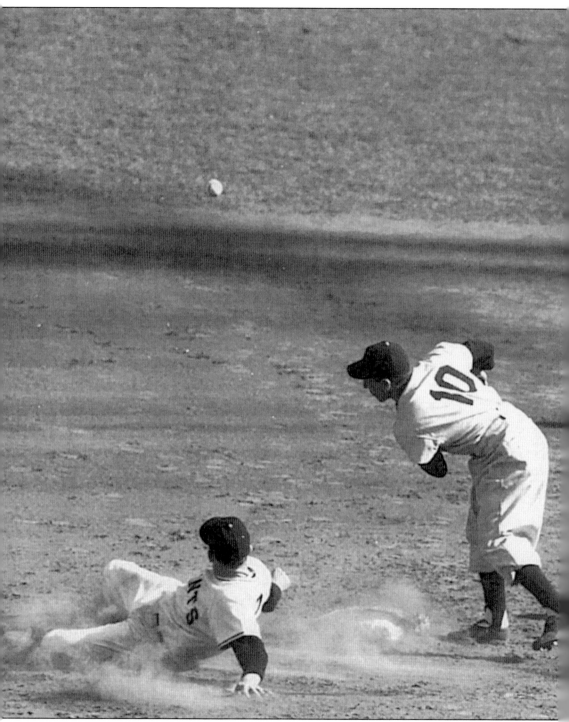

WORLD SERIES ACTION, 1951. Shortstop Phil Rizzuto watched the ball sail away after a sliding Eddie Stanky kicked it out of his glove in the third game of the 1951 World Series. Stanky's

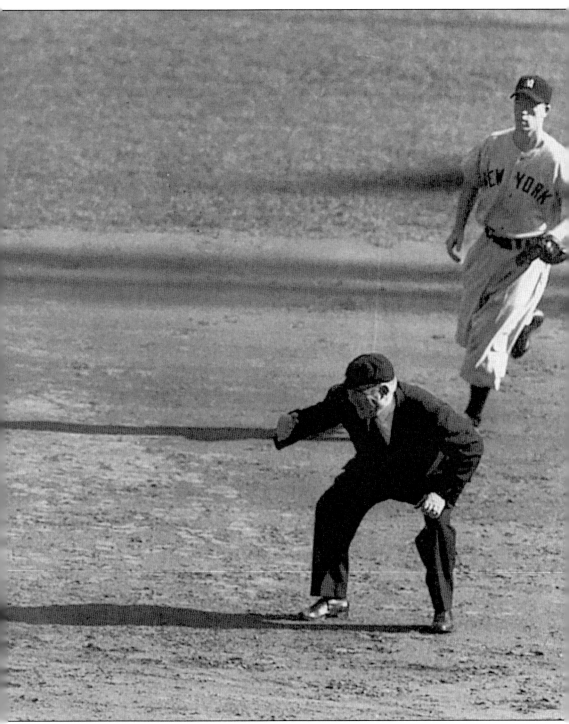

aggressive play sparked the Giants to a 6-2 victory and put them up two games to one.

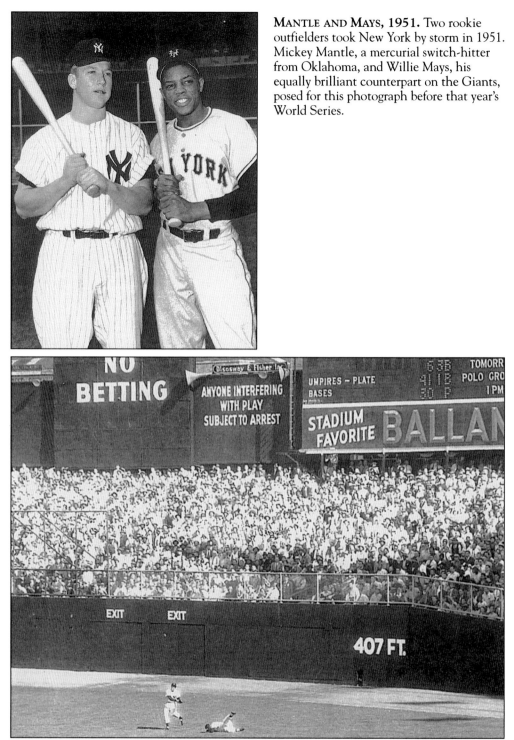

MANTLE AND MAYS, 1951. Two rookie outfielders took New York by storm in 1951. Mickey Mantle, a mercurial switch-hitter from Oklahoma, and Willie Mays, his equally brilliant counterpart on the Giants, posed for this photograph before that year's World Series.

A BAD TURN. In the second game of the 1951 World Series, Mickey Mantle twisted his knee chasing a fly ball in right field at Yankee Stadium. The accident prematurely ended Mantle's season and foreshadowed an injury-plagued career.

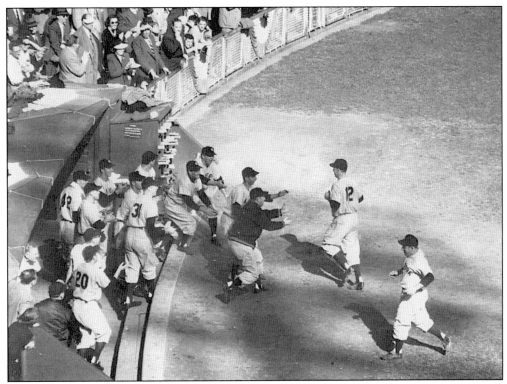

SLAMMING THE DOOR. After dropping two of the first three games of the 1951 World Series, Casey Stengel angrily asked his club, "Are you going to let those garbage collectors steal your money?" The answer was no. The Yankees won game four, 6-2. In game five, Gil McDougald's grand slam (pictured here) paced a 13-1 rout. Then, the following day, the Yanks closed out a second straight championship with a 4-3 win.

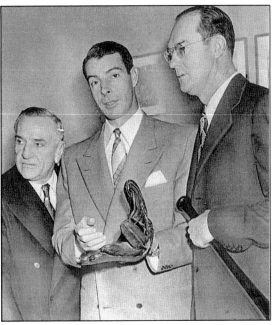

DiMAGGIO RETIRES. With his manager and co-owner Dan Topping flanking him, Joe DiMaggio announced his retirement on December 11, 1951. He left behind a spectacular record—361 home runs and a .325 batting mark over 13 seasons, during which he helped guide the Yankees to 10 pennants and nine championships. Only 37 years old, and earning $100,000 a year, DiMaggio might have played a couple of more seasons. He quit "because he couldn't be Joe DiMaggio anymore," his brother Tom explained.

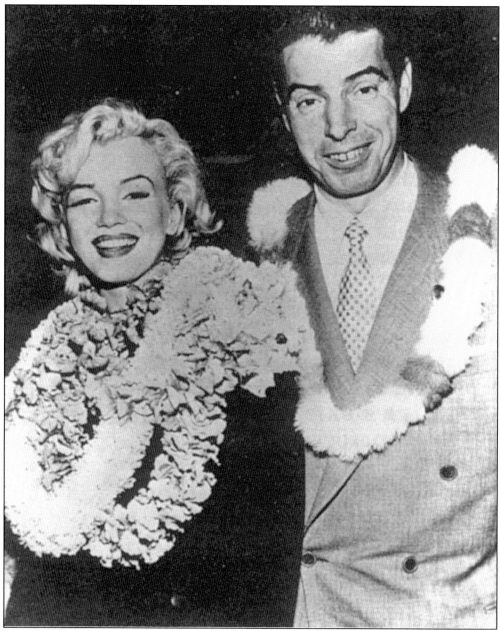

JOE AND MARILYN. Although their marriage lasted less than a year, the union of baseball's greatest name and the world's most glamorous blonde starlet seized the national imagination during the 1950s. A reporter once asked DiMaggio to describe the experience of taking a shower with Marilyn Monroe, whose physical assets had graced a famous calendar. "Louie," responded DiMaggio, "you should've been there."

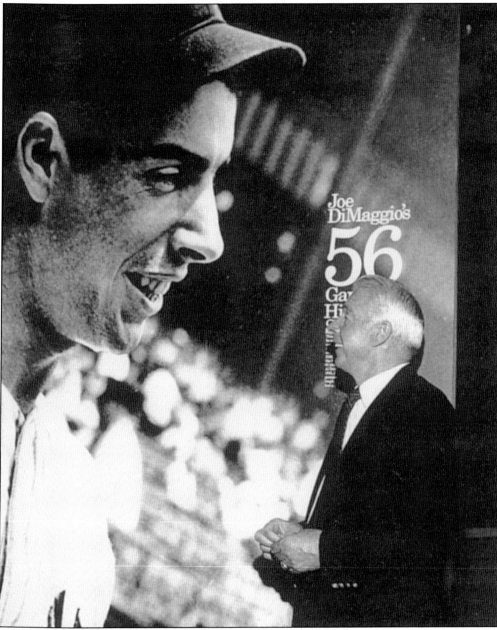

WHERE HAVE YOU GONE? DiMaggio, who was inducted into the Baseball Hall of Fame in 1955, later returned to Cooperstown to look over the exhibit honoring his 56-game hitting streak. Long before his death in 1999, DiMaggio was immortalized in literature by Ernest Hemingway and in verse by Paul Simon, who sang, "Where have you gone, Joe DiMaggio?/A nation turns its lonely eyes to you./What's that you say, Mrs. Robinson?/Joltin' Joe has left and gone away."

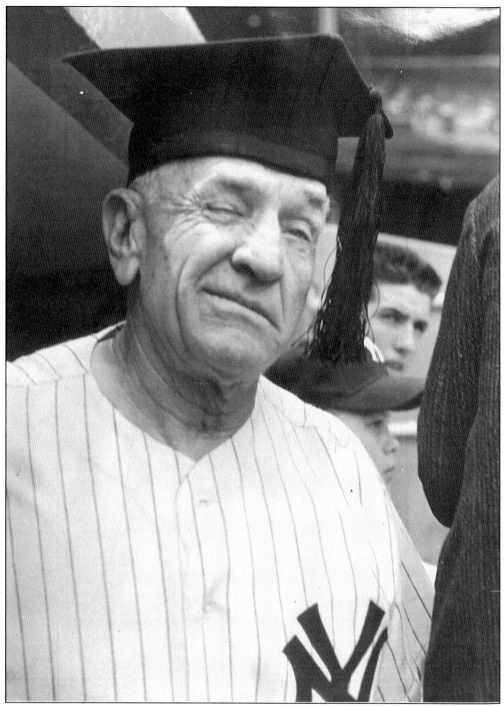

THE OL' PERFESSER. The postwar explosion of electronic media coverage helped the country fall in love with the winking, mugging, double-talking, grandfatherly fellow managing the Yankees. Casey Stengel's antics were at odds with the club's bloodless corporate image, but the bottom line was that like Miller Huggins and Joe McCarthy before him, he won—again and again.

Six

STENGELESE SPOKEN HERE

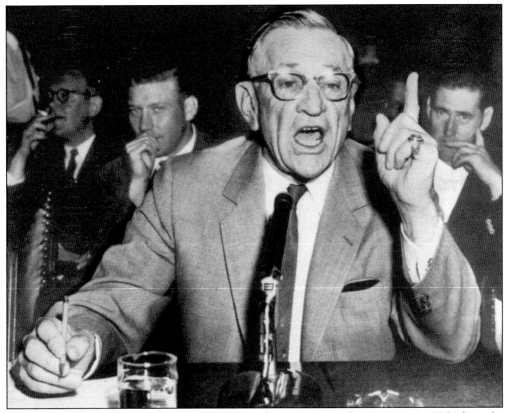

SAY WHAT? Stengel's meandering testimony before a Senate subcommittee in 1958 brought national attention to the phenomenon known as "Stengelese." Casey had always talked fast, words tripping over each other as his speech tried to keep pace with his lightning-quick wit and powers of observation and recall. Stengel could be devastatingly clear when he wanted to make a point, frustratingly vague when he wished to avoid answering a question, and marvelously entertaining in either case.

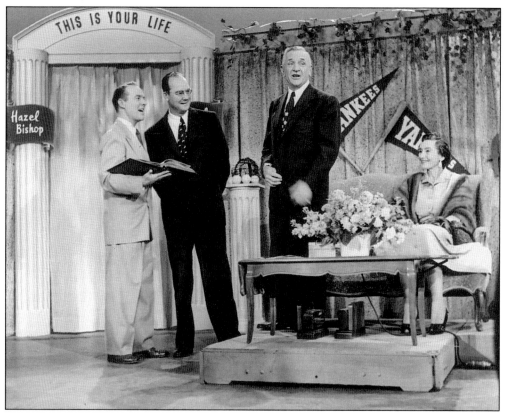

CASEY'S LIFE. Casey, accompanied by his wife Edna, was toasted in a 1952 episode of *This Is Your Life*. His life story included growing up in Kansas City, Missouri; abandoning dental school for a 14-year big-league playing career; two World Series championships as an outfielder with the New York Giants; and a managerial career notable for its extreme highs and lows. After managing Brooklyn and the Boston Braves to nothing but second-division finishes in the 1930s, he guided the Yankees to ten pennants and seven world championships between 1949 and 1960. After that came his storied tenure as manager of the woeful New York Mets, followed by a berth in the Baseball Hall of Fame.

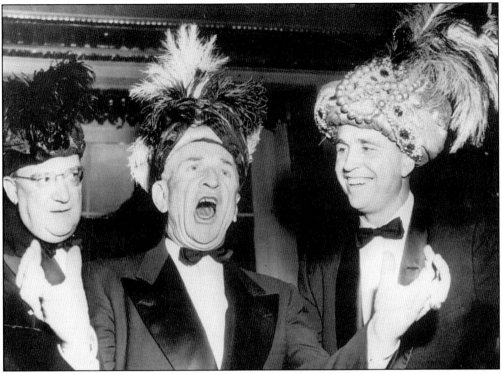

PART CLOWN, PART ELEPHANT. Despite his image as a clown, Casey was no dummy. "I found out he was as smart a manager as he was made out to be," said Mel Harder, his pitching coach with the Mets. "I was surprised because when he was with the Yankees I used to think anybody could do it with the players he had. But he made moves that worked out because he knew the history of each player against each team and each pitcher. Casey was like an elephant. He always remembered what every player did and he could capitalize on it."

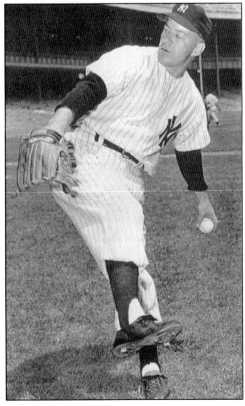

THE JUNKMAN. Eddie Lopat, a mainstay of the teams that won five straight World Series between 1949 and 1953, was born Edmund Walter Lopatynski in New York City. He earned his nickname, "The Junkman," through a variety of off-speed pitches. They were effective enough to produce a 113-59 record as a Yankee, including a 16-4 mark in 1953, when he led all pitchers with a 2.42 ERA. He was 4-1 in World Series play.

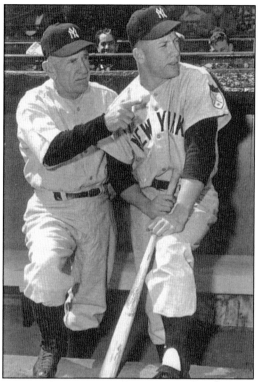

PROFESSOR AND PUPIL. Here is a 1951 shot of Stengel with his prize pupil, 19-year-old Mickey Mantle. "Casey became almost like a father to me," said Mantle, whose own father died after his rookie season. "He always called me 'my boy.' He loved to brag to the press about me. He would tell them I was going to be the next Babe Ruth, Lou Gehrig, and Joe DiMaggio all rolled into one."

ALL IN THE FAMILY. Like DiMaggio, Mantle had a pair of ball playing brothers. Both Ray (left) and Roy (right) Mantle played in the Yankees' farm system, though neither was able to make it to the big leagues.

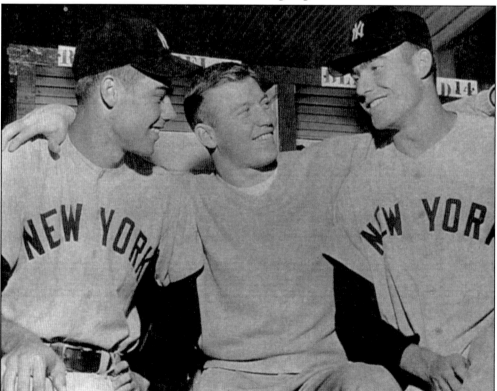

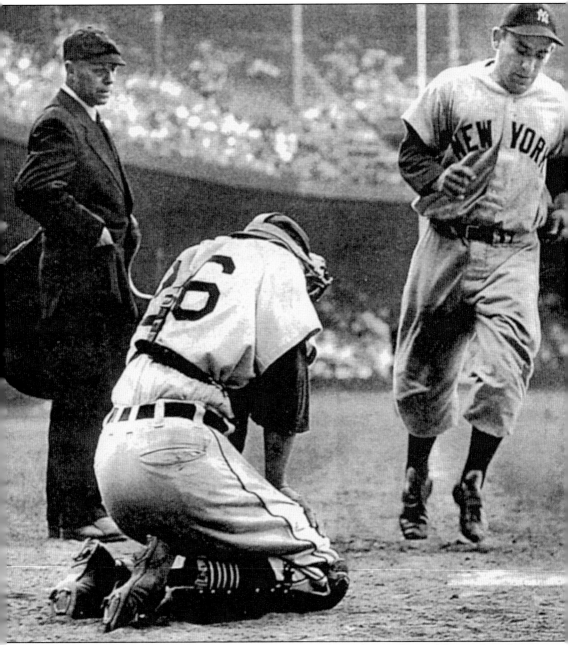

YOGI BERRA, 1951. Peter Lawrence "Yogi" Berra crossed the plate in front of dejected catcher Joe Ginsberg after one of his 358 career home runs provided the winning runs in an extra-inning game in Detroit. Berra, a St. Louis native and Navy veteran who had fought on a rocket ship off Omaha Beach on D-Day, was a homely, garrulous, and utterly original character, but he probably did not author half of the malapropisms attributed to him. He was a superlative catcher and clutch hitter; he may have been the best bad-ball hitter in history. Stengel called him "my assistant manager," a tribute to his field leadership. Berra appeared in a record 14 World Series, won MVP awards in 1951, 1954, and 1955, and was elected to the Hall of Fame in 1972.

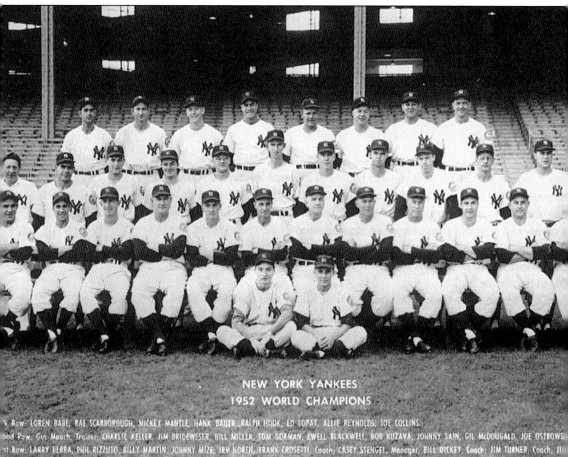

NEW YORK YANKEES
1952 WORLD CHAMPIONS

k Row: LOREN BABE, RAE SCARBOROUGH, MICKEY MANTLE, HANK BAUER, RALPH HOUK, ED LOPAT, ALLIE REYNOLDS, JOE COLLINS.
nd Row: Gus Mauch, Trainer; CHARLIE KELLER, JIM BRIDEWESER, BILL MILLER, TOM GORMAN, EWELL BLACKWELL, BOB KUZAVA, JOHNNY SAIN, GIL McDOUGALD, JOE OSTROWS
at Row: LARRY BERRA, PHIL RIZZUTO, BILLY MARTIN, JOHNNY MIZE, IRV NOREN, FRANK CROSETTI, Coach; CASEY STENGEL, Manager; BILL DICKEY, Coach; JIM TURNER, Coach; JI
E WOODLING, CHARLIE SILVERA. Bat Boys: JOE CARRIERI and

THE CLASS OF '52. Casey Stengel's 1952 Yankees squeaked past Cleveland by two games, thanks to a league-low 3.14 ERA and league-high .267 batting average. Outfielder Gene Woodling (front row, second from the right) hit .309, second only to Mantle's .311. "I didn't consider myself a celebrity," said Woodling, one of the many role players Stengel expertly moved in and out of the lineup, "and publicity and fame wasn't important to me. I just liked getting a sizeable paycheck and realizing I didn't have to work for a living."

108

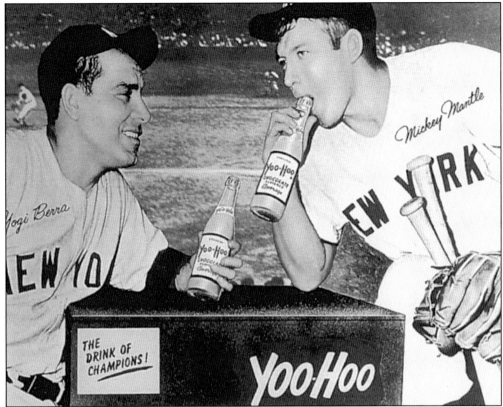

YANKEES AND YOO-HOO. Playing in the media capital of the world allowed Yankees' stars to supplement their salaries by endorsing a wide variety of products. Yogi Berra and Mickey Mantle plugged Yoo-Hoo chocolate pop, the self-styled "Drink of Champions."

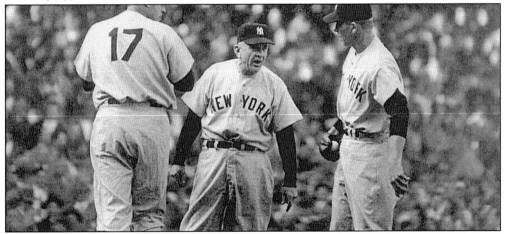

TIME FOR A CHANGE. Stengel often paid more attention to his hunches than percentages. With the bases loaded and one out in the seventh inning of the final game of the 1952 World Series, he brought in Bob Kuzava (right) to put down a Brooklyn rally. "Stengel stayed with Kuzava, although he was a left-hander facing the Dodgers' predominantly right-handed lineup," remembered fellow reliever Johnny Sain. "He just poured in fastballs and retired the next eight batters to give us the championship."

BILLY TO THE RESCUE. The most dramatic play of the 1952 World Series occurred in the seventh inning of the seventh game. With the bases loaded, two outs and a full count, Jackie Robinson popped up a Bob Kuzava pitch that almost turned into disaster for the Yankees. Both Kuzava and first baseman Joe Collins unaccountably froze, forcing second baseman Billy Martin

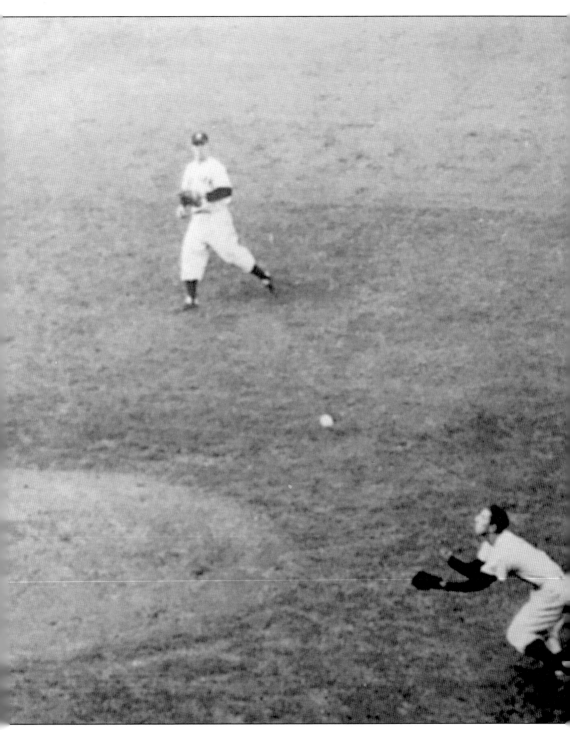

to race in and make a shoetop catch near the mound. Had the ball fallen to the ground, all three Brooklyn runners probably would have scored. As it was, Martin's heads-up play preserved a 4-2 lead, and the Yankees went on to win yet another championship at the Dodgers' expense.

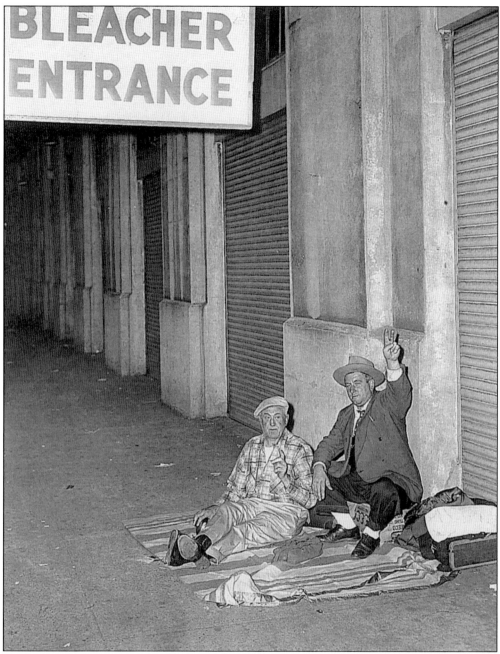

FIRST IN LINE. The Bombers rolled to a fifth straight pennant in 1953, winning 99 games to finish eight games ahead of the Indians. For the fifth consecutive October, loyal Yankees rooters Ralph Belcore (left) and Charles Kierst staked out their places in line for bleacher tickets to the opening game of the World Series.

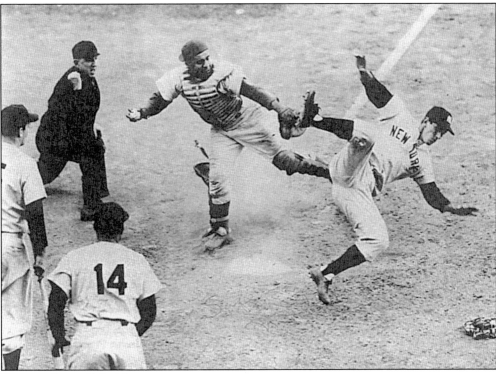

BOWLED OVER. Billy Martin was sent sailing ungracefully through the air after being tagged by Brooklyn catcher Roy Campanella for the final out of the fourth game of the 1953 World Series. New York lost, 7-3, but thanks to Martin's dozen hits and .500 batting average, they went on to take the series in six games.

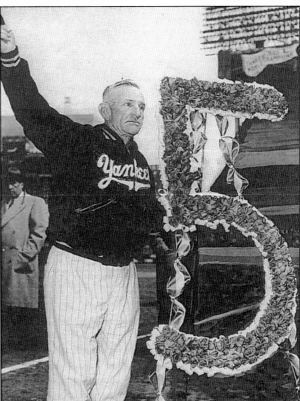

FIVE IN A ROW. It was the home opener of the 1954 season, and Casey Stengel acknowledged the Yankee Stadium cheers after accepting a floral numeral indicating the Yankees' unprecedented fifth straight championship. Despite 103 victories in 1954, the Yankees' bid for a sixth straight title fell short when Cleveland won a record 111 games.

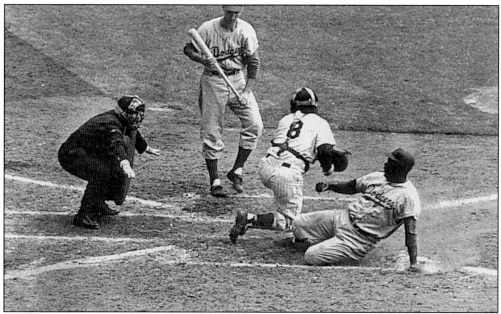

SAFE? NO WAY! Yogi Berra turned to argue the call after Jackie Robinson stole home during the 1955 World Series. After beating Brooklyn in the 1941, 1947, 1949, 1952, and 1953 World Series, New York finally fell to the Dodgers, losing in seven games.

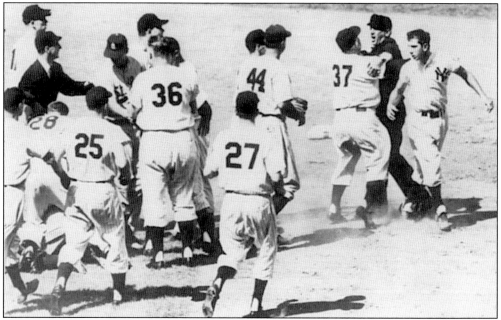

BRASH BILLY. Casey Stengel intervened in a fight involving Billy Martin and St. Louis Browns catcher Clint Courtney. The scrappy Martin was a Stengel favorite and possibly misunderstood. "Everybody had the wrong idea about him," insisted teammate Ewell Blackwell. "He was a fiery guy who'd fight you at the drop of a hat if you did something wrong to him—but he only fought players on the other team."

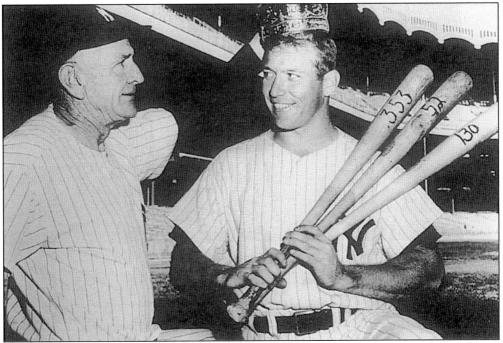

CROWNED. Stengel coronated Triple Crown winner Mickey Mantle, who in 1956 hit .353 with 52 homers and 130 RBI. One of Mantle's drives that season soared an estimated 565 feet at Washington's cavernous Griffith Stadium. "Mantle was always amazing," said teammate Bob Turley. "They say that if he would have taken better care of himself he would have been a lot better off. I don't know if I agree with that. I'd seen him come to the park as fit as a fiddle at times and having been out on the town all night at other times, and he might have had a better game in the latter condition."

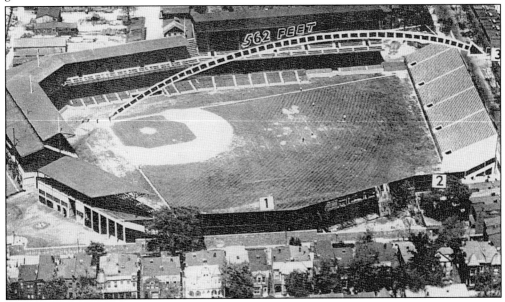

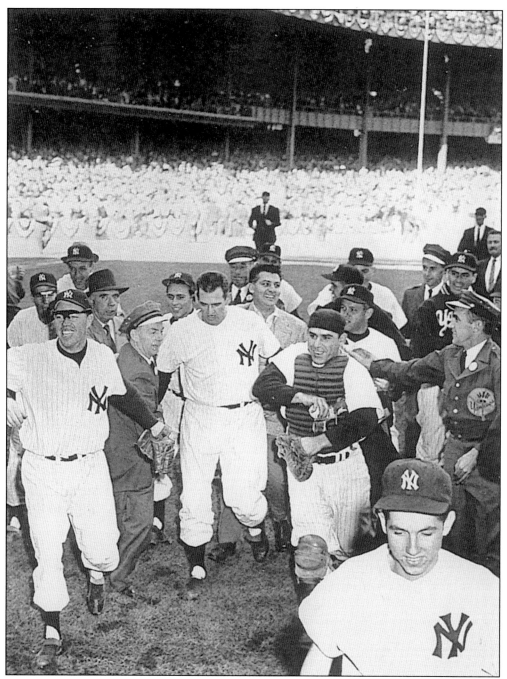

PITCHER PERFECT. On October 8, 1956, Don Larsen hustled off the field after pitching the only perfect game in World Series history. Confusing Brooklyn with a no-windup delivery, the 27-year-old journeyman—who won only 11 games during the season—retired 27 straight batters in a 2-0 victory. "We didn't like being his victim," said Brooklyn's Rube Walker, "but we had to give him credit—some of the guys would tell me that since we weren't going to beat Larsen that day they were rooting for him." The Yankees avenged their loss to Brooklyn in the 1955 World Series by beating them for their sixth championship in eight years under Stengel.

A PIPELINE TO THE BRONX. During the 1950s, the lowly Kansas City Athletics regularly provided the Yankees with such prospects as pitcher Ralph Terry (pictured), who would win two games in the 1962 World Series. The teams' collusion could be traced to the close association between Athletics owner Arnold Johnson and Yankees co-owners Dan Topping and Del Webb, which dated back to the Chicago millionaire's purchase of Yankee Stadium and Blues Stadium. Kansas City, a former Yankees farm team, completed 16 trades involving 60 players with New York between 1955 and 1960.

A JOY TO WATCH. Clete Boyer, a laid-back small-town kid from Missouri, came over from Kansas City in 1959. "He was such a great third baseman," said teammate Joe DeMaestri. "He was always making diving stops or charging topped balls and throwing out speedy runners. I just loved to watch that guy."

117

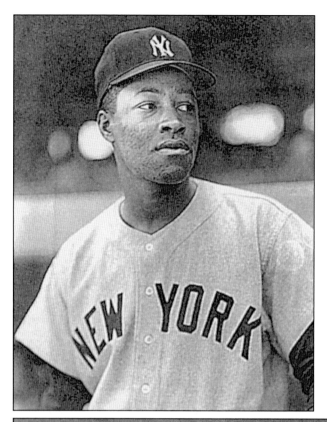

BREAKING THE COLOR BARRIER.
Elston Howard was the Yankees'
first African-American player,
arriving in New York in 1955 and
staying through 1966. Employed
as a catcher and an outfielder,
the slow-footed Howard batted
as high as .348 in 1961 and was
named Most Valuable Player in
1963. What took the Yankees so
long to integrate? "The truth,"
general manager George Weiss
told sportswriter Roger Kahn
in 1954, "is that our box seat
customers from Westchester
County don't want to sit with a
lot of colored fans from Harlem."

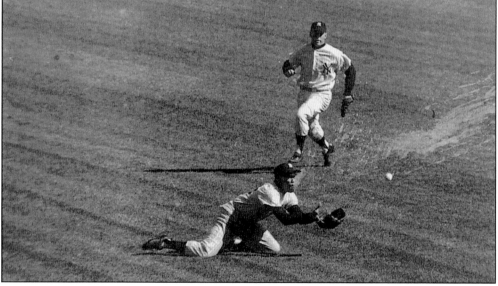

WILD MAN. Ryne Duren came to the Bronx from Kansas City in 1958 and immediately led the league with 20 saves. His 100-mph fastballs and lack of control on and off the field kept batters on edge. "He threw the first warm-up pitch into the stands and my legs started shaking," said Cleveland's Vic Power, recalling a typical encounter. Duren defended his use of dark, thick glasses, which made him appear to be blind. "My eyes weren't good to begin with, and lots of times I was hung over."

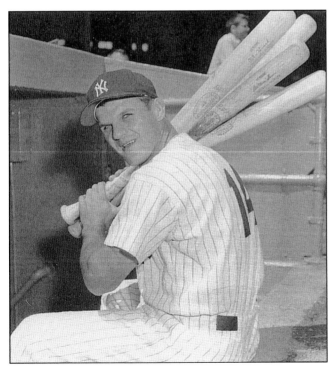

MOOSE SKOWRON. First baseman Bill Skowron enjoyed five .300 seasons during his nine years at Yankee Stadium and was usually good for 20 home runs and between 80 and 90 RBI each year. "Bill was a Polish guy who we all called 'Moose' because he had a crew cut like Mussolini had," said Bob Turley. "He was a friendly, naive guy who everyone liked to kid. We all liked Moose."

A RECORD DOZEN. Bobby Richardson, a slender second baseman from Sumter, South Carolina, batted .266 between 1955 and 1966 for the Yankees. Richardson would be the unexpected star of Casey Stengel's last World Series, knocking in a record 12 runs in the seven-game loss to Pittsburgh in 1960.

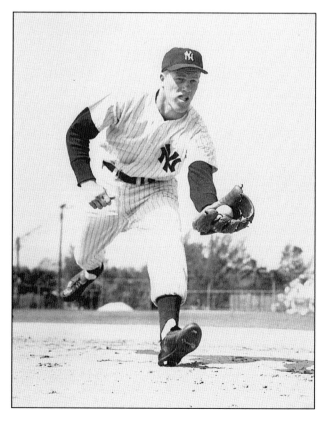

TONY KUBEK. A Milwaukee native with a ready smile and a steady glove, all-purpose Tony Kubek played as many as seven positions for Stengel, including five in a single World Series game. Kubek won the American League Rookie of the Year Award in 1957 and spent nine years in pinstripes before entering the broadcast booth.

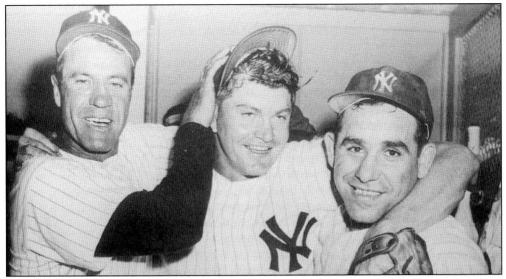

NAKED JOY. From left to right, Hank Bauer, Bob Turley, and Yogi Berra celebrated an extra-inning win in the sixth game of the 1958 World Series against Milwaukee. Turley, a 21-game winner that year, retired the final batter with two runners on base to preserve the 4-3 victory. Afterwards, Ryan Duren, who struck out nine to gain the decision in relief, was interviewed for the next morning's *Today* show. "I was looking forward to seeing myself," he recalled, "but they had to cut the segment because Yogi Berra had been walking around buck naked in the background scratching his rear end."

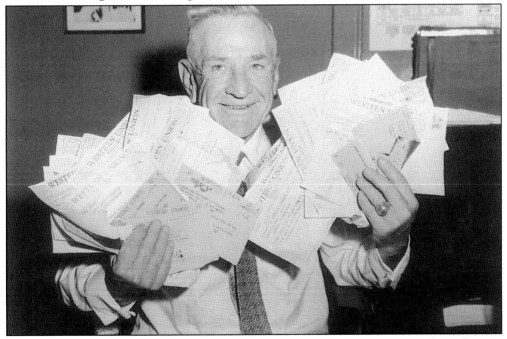

CONGRATULATIONS, CASEY. Casey Stengel held some of the telegrams congratulating him on a thrilling comeback win over the Braves in the 1958 World Series. The Yankees, who lost the previous year's series to Milwaukee in seven games and were down three games to one in the rematch, won the last three games to notch Casey's seventh and final championship.

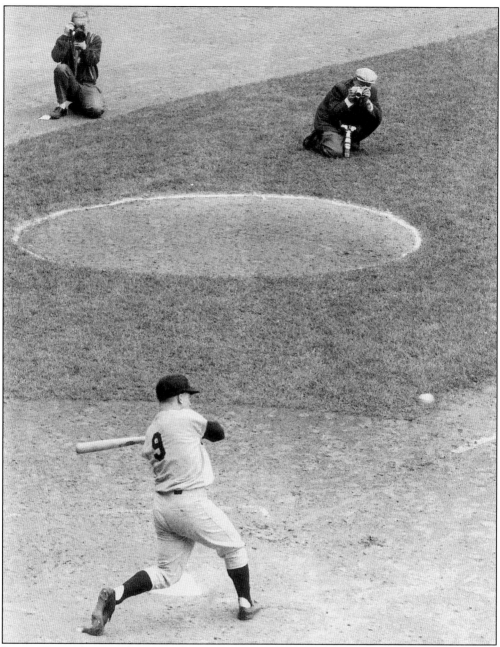

SWING TIME. Photographers zeroed in on the home run swing of Roger Maris, the more taciturn half of the Yankees' famous "M & M Boys" of the early 1960s.

Seven

RELUCTANT HERO

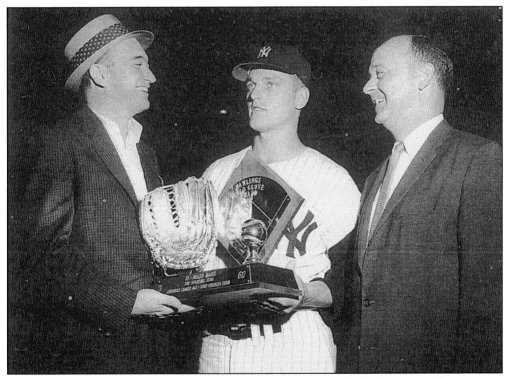

EXCELLENCE REWARDED. Roger Maris received the 1960 Gold Glove Award, a year in which the Yankees' right fielder also won the first of two straight MVP awards. Maris was a multidimensional star even before he came to New York from Kansas City prior to the 1960 season. "He hit line drives, had speed on the base paths, a great arm, excellent range in the outfield," summarized Mickey Mantle. In his first season in pinstripes, Maris hit 39 home runs and led the loop in RBI and slugging percentage.

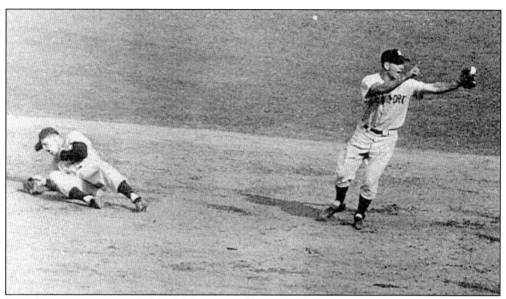

THE AGONY OF DEFEAT. Bobby Richardson calls time as shortstop Tony Kubek holds his aching Adam's apple, the result of a bad-hop grounder off the bat of Pittsburgh's Bill Virdon in the eighth inning of the seventh game of the 1960 World Series. The sure double-play ball opened the floodgates for the Pirates, who erased a 7-5 Yankees lead with four runs. New York tied it in the ninth, but in the bottom of the inning Bill Mazeroski hit the most famous home run in World Series history to give the underdog Pirates a wild 10-9 win and the championship.

ONE COMING, ONE GOING. Casey Stengel and coach Ralph Houk are pictured here in the Yankees' dugout. Stengel is holding a push broom, an appropriate prop since he was broomed by Yankees' management two days after New York lost the 1960 World Series. Houk, a former army Ranger and back-up catcher, skippered New York to three straight pennants, 1961–63, and World Series titles in 1961 and 1962 before giving way to Yogi Berra. Stengel, accused of being an old man out of touch with the times, grumbled, "I'll never make the mistake of being 70 again."

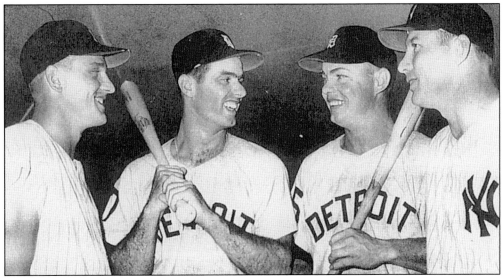

A RECORD SUMMER. The 1961 edition of the Bronx Bombers featured unprecedented slugging, with the Yankees hitting a record 240 homers in a season that was expanded from 154 to 162 games. That summer, Maris and Mantle (with Detroit stars Rocky Colavito and Norm Cash) led the Yankees to a team record 109 victories, placing them eight games ahead of the Tigers.

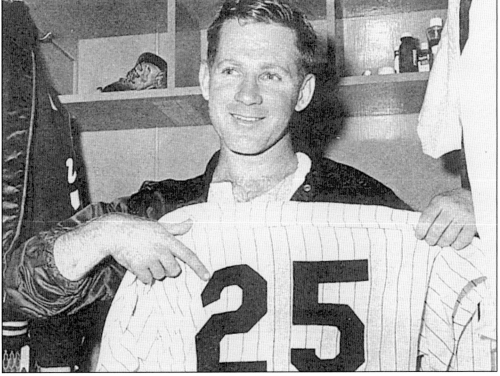

A BAD YEAR FOR THE BABE. Not only did Babe Ruth's home run record fall in 1961, his World Series mark of 29.2 consecutive scoreless innings was erased by Whitey Ford, who had his finest season with a 25-4 record. "I guess it was a bad year for the Babe," said the Cy Young Award winner, who beat Cincinnati twice as the Yankees won the World Series in five games.

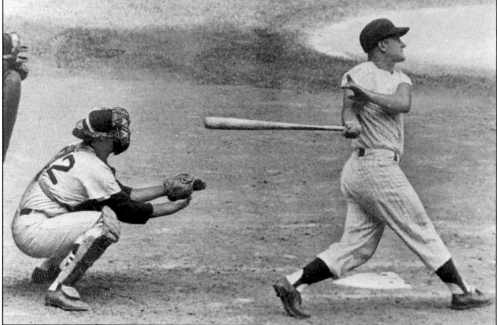

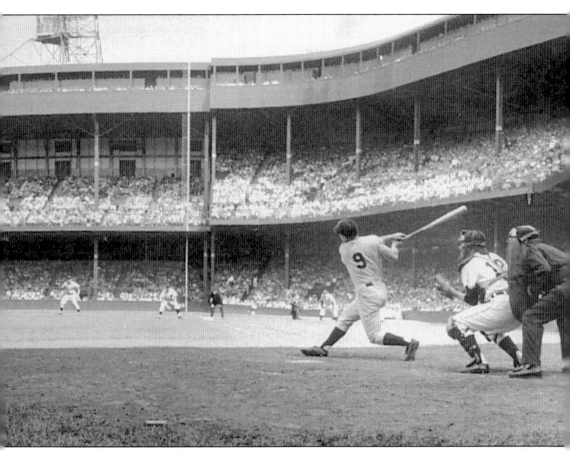

ONE HOME RUN CLOSER. The biggest story of the summer was Mantle and Maris's pursuit of Ruth's home run record of 60. Most fans and reporters favored Mantle, but he ultimately was sidelined by injuries in September and finished with 54. Maris doggedly continued, despite suffocating media coverage that caused some of his hair to fall out. With a full house on hand at Tiger Stadium, the third deck press area overflowing with reporters, and a runner on first base, Maris belted a Terry Fox pitch into the seats for home run number 58 on September 17, 1961.

THE RECORD BREAKER. Maris smacked his 61st home run on the final day of the season off Boston's Tracy Stallard, breaking Ruth's hallowed single-season record. Commissioner Ford Frick ruled that an asterisk be placed by Maris's achievement, as it came in an extended season—a ruling that further alienated the 27-year-old slugger.

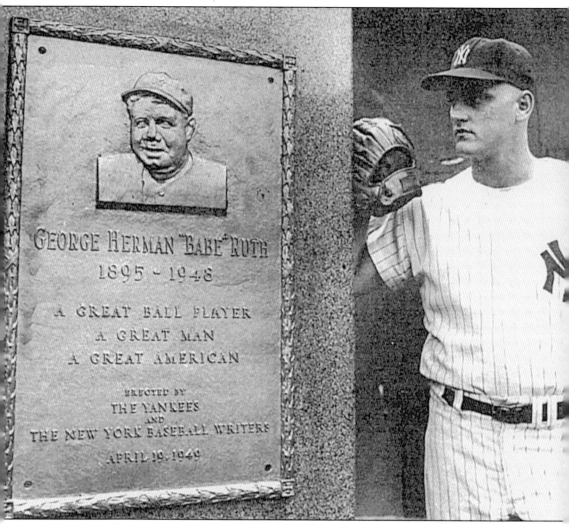

NOT GOOD ENOUGH. Roger Maris "slumped" to 33 home runs in 1962, and although the team prospered, beating San Francisco for its last world championship until 1978, Maris was made miserable by unrelenting comparisons to the American icon whose record he had dared eclipse. Breaking Ruth's record "became a haunting experience for Roger," Mantle said. In 1962, "fans gave him the worst beating any ballplayer ever took. I guess they expected him to hit 62 home runs." Maris averaged only 17 home runs in the seven seasons after 1961, the last two of which were spent in St. Louis. By then, the Yankees had fallen into disrepair, finishing last in 1966 for the first time in 58 seasons. New Yankees' mini-dynasties would appear in the 1970s and 1990s, but they would never approach the kind of sustained domination that marked the club during its golden age.